LM

Meinrad Martin Froschin

A Beginner's Guide to
Airbrushing

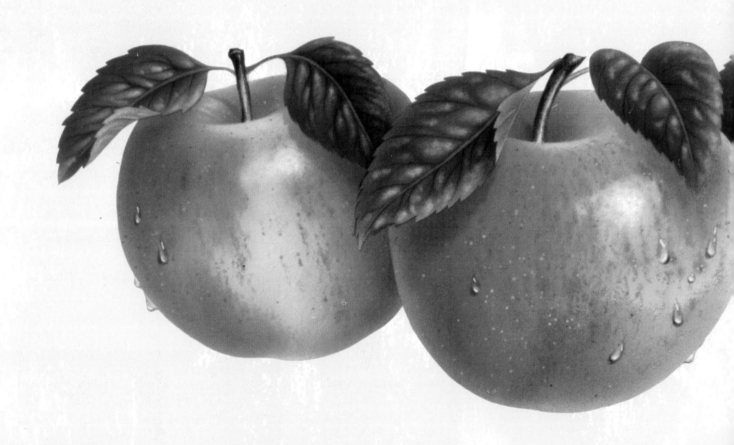

Meinrad Martin Froschin

A Beginner's Guide to Airbrushing

Text by Meinrad Martin Froschin and Manfred Braun

Search Press

Contents

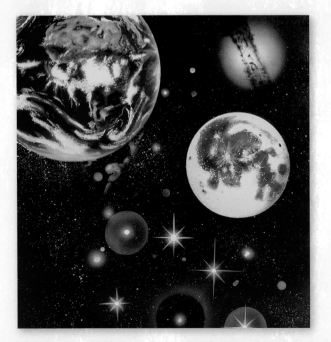

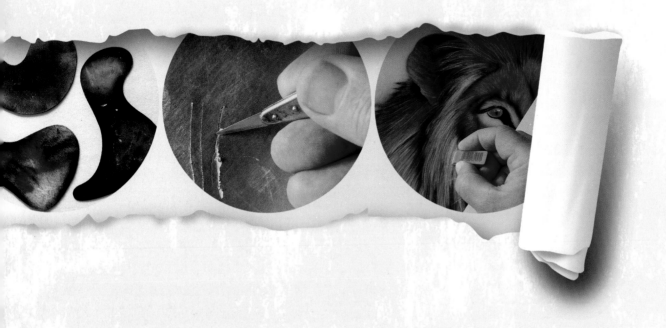

Introduction – my technique

Rather than describing airbrushing in general, this book is a detailed guide on how to apply my preferred technique of combining transparent paints with erasing to achieve fantastic photorealistic artwork.

Over the last few decades I have written about this technique in over 120 articles published in international airbrushing journals, videos, DVDs and books. I first developed it in the 1980s, and it has since been adopted by many artists working with transparent colours. This book is the most comprehensive manual I have compiled for those new to the art of airbrushing and who want to master my technique. However, I do cover other techniques as needed (for instance, I am no fan of masking film, but I do know how to use it when necessary).

Additionally, this book will be ideal for anyone who either has just bought airbrushing equipment or is planning to do so. If you are still in the planning phase, then use this book as a guide for buying the right equipment and materials. If you have already bought the equipment, then refer to this book to establish whether you have bought the right tools or whether you are still lacking essential items.

Please note that none of the images used here were created or refined in a sterile photography studio – they were all created in my personal workshop – that is why many of the tools show signs of having been used (it's deliberate!). After all, I work with pigments and colourants, which tend to leave traces behind. Over the next few chapters, you will get a clear impression of both my working environment and how I work. My workspace has developed gradually over more than thirty years, and I am constantly improving it.

Ultimately, I hope that my book will give you the benefit of my many years of experience with both my basic technique and the tools needed to achieve it.

With any luck, you'll have mastered the basics of my airbrushing style in no time.

Happy airbrushing!

Meinrad Martin Froschin

Workplace and working materials

When it comes to your airbrush equipment never skimp on quality. The quality of your equipment is important; good equipment will make your work easier and stress-free in the long run.

You will need a compressor, an airbrush gun/spray device (which I simply call an 'airbrush' throughout the book), suitable paints and a firm Bristol board for practising on. A few extra items, ranging from coloured pencils to adhesive tape, will complete the set.

My workspace

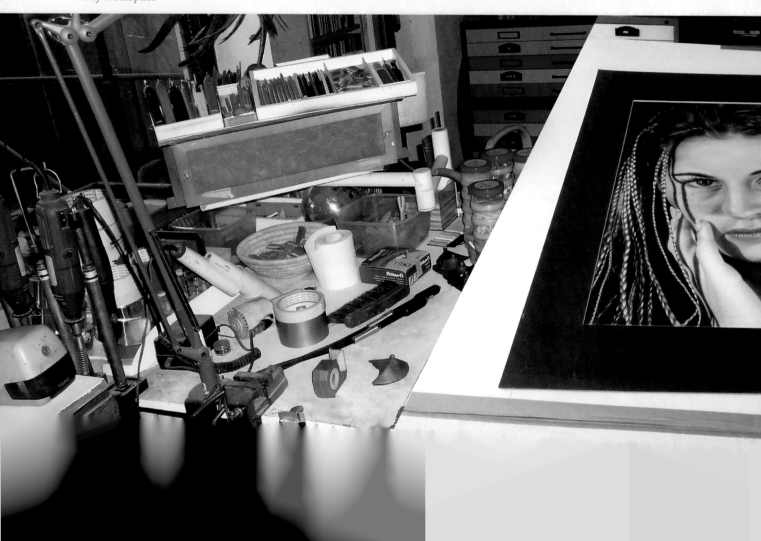

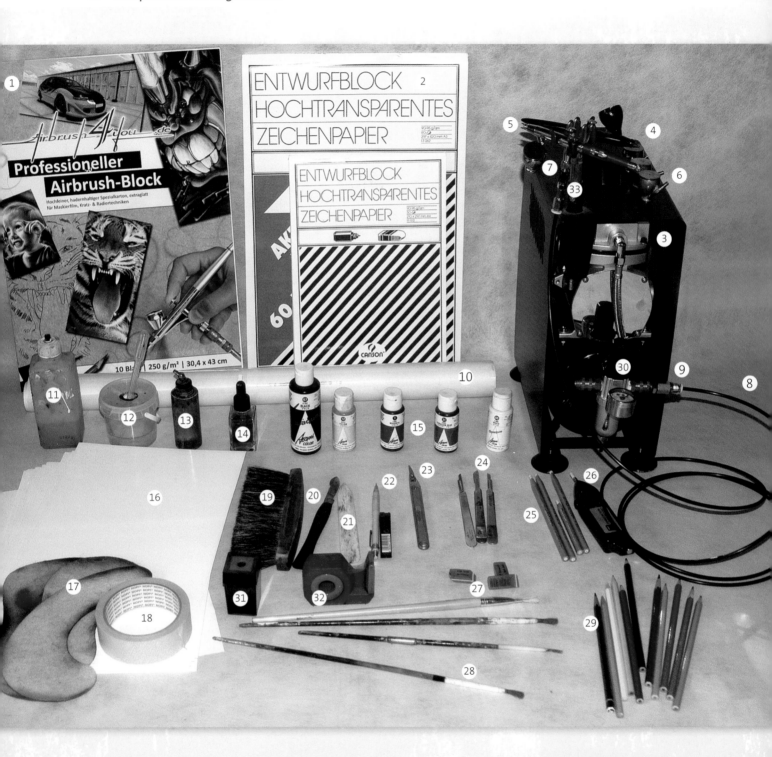

The complete starter set

1 Professional airbrush pad or board

2 Tracing paper and sketch pad

3 Compressor, the compressed air source

4 Gravity feed airbrush

5 Suction feed airbrush

6 Suction feed cup

7 Mini coupler

8 Hose connecting airbrush and compressor

9 Coupler between hose and compressor

10 Masking film

11 Water bottle

12 Water cup with eyedropper

13 Suction feed bottle with water

14 Acrylic cleaner

15 Acrylic paints: black, yellow, magenta, cyan and white

16 Stencil cardboard for use as scrap paper

17 General purpose stencils, kidney shaped

18 Adhesive tape

19 Crumb brush

20 Erasing knife

21 Folding stick

22 Propelling pencil, 0.5mm HB with refill leads

23 Pointed scalpel for cutting

24 Rounded-blade scalpel for scraping

25 Eraser pencils

26 Electric eraser

27 Rubber erasers

28 Various paintbrushes

29 Coloured pencils

30 Compressor pressure regulator

31 Pencil sharpener

32 Clear adhesive tape

33 Airbrush holder

Support and masking material

Airbrush board as support

The support, your illustration board, should have a basic weight of at least 250gsm (8.8oz). The board is available in single sheets (A4, A3/American letterhead or larger) or in pads.

The minimum weight of 250gsm (8.8oz) is necessary if you want to be able to use all the techniques described in this book. Thinner paper or a lower-quality support can buckle if paint is applied thickly, sheds lint during erasing, or tears when scraped. That would quickly bring work to a halt and hinders creativity.

Tracing paper for your sketch

This is the paper you draw your sketches on before transferring them onto the illustration board using a folding stick (see page 59, Transfer method).

Tracing paper is available both in pads (A4 and A3/ American letterhead or larger) and in rolls sold by length. The basic weight of such paper should be at least 90 to 95gsm (3 to 3.4oz).

Stencil material for masking

General purpose stencils are commercially available in numerous shapes, but making your own is cheaper. Once you have worked with them for a while, you will very soon find out which curves and shapes you use repeatedly and then you will be able to make your own stencils. I now have somewhere around thirty to forty different shapes.

Many kinds of paper and sheet material are suitable for stencils. I like working with Pellon (a non-woven fabric made from synthetic fibres), but for one-offs also use industrial cardboard with a weight of at least 200gsm (7oz) of the kind also used for printing calendars.

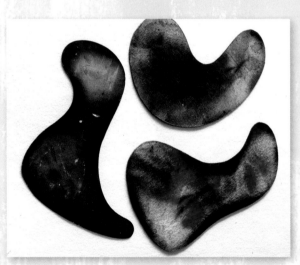

General purpose stencils. These are technical drawing stencils with various curves. I produce stencils which I use again and again using 600gsm (21.16oz) Bristol board and Pellon of various thicknesses.

You can start off with simple paper stencils so you can develop your own routine. Paper of at least 150gsm (5.3oz) is sufficient for practising as it is reasonably stable and does not buckle even after repeated spraying.

Masking film for sharp edges

Standard commercial masking film is slightly adhesive and transparent, and is used particularly when very hard edges are required, as in technical illustrations. Since masking film is transparent it can be cut to size very accurately.

In technical drawings, like this bicycle sprocket, the sharp edges are obtained by using self-adhesive masking film.

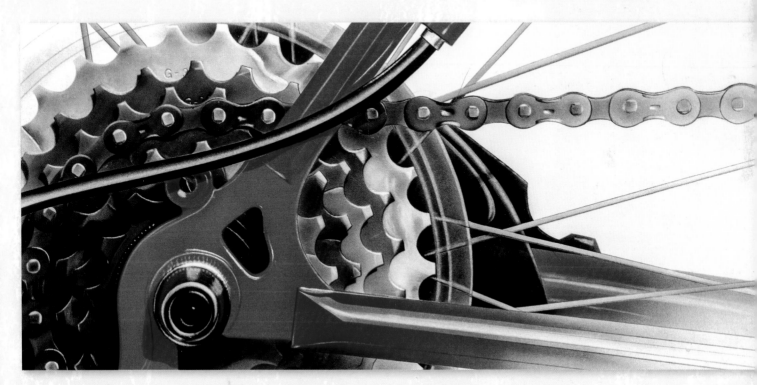

Paints and pencils

Airbrush acrylic paints

Airbrush paints are widely available from art supply manufacturers. The differences between different brands are minimal, except in terms of colour palette. One paint may adhere better (due to a higher binder, i.e. acrylate, content) while another may be more highly pigmented. These include Schmincke's Aero Color paints, which I have been using successfully for thirty-five years because they are ideal for my erasing technique. All the illustrations in this book were made using this paint.

You can stock up with dozens of pre-mixed colours, but you can start out perfectly well with the primaries: black, magenta, yellow and cyan. Sensible additions to the colour spectrum could be Brilliant Green, Gold Ochre, Sepia Brown, Red Orange and Ultramarine.

If you want to mix colours, then these shades will be quite sufficient. If you find that too troublesome, then you can make use of the countless commercially available colour shades.

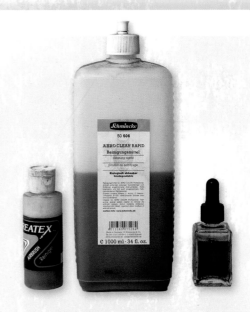

Airbrush cleaner is a solvent that softens and liquefies dried acrylic paints and so is indispensable for cleaning your airbrush, brushes and entire working area.

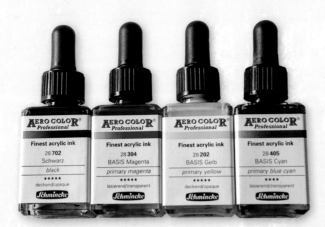

Airbrush primaries. These are black, magenta, yellow and cyan water-based acrylic paints.

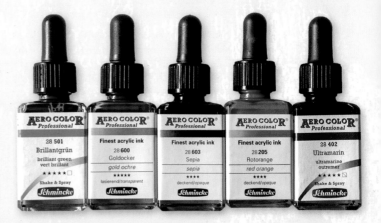

These five further acrylic paints make a sensible addition to the primaries.

Coloured pencils

For me, coloured pencils are the perfect complement to an airbrush. Where airbrushing stops, coloured pencils and erasers start, and vice versa.

Coloured pencils allow you to create textures that an airbrush is not designed to do.

A selection of coloured pencils for additional design work. Altogether I have eight drawers like this, containing pencils sorted by colour.

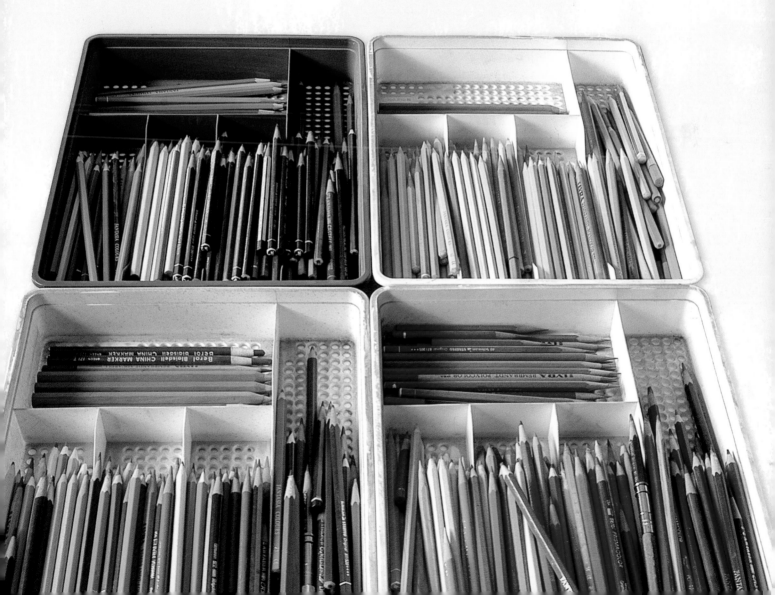

Tools of the trade

Folding stick

I primarily use the folding stick to transfer a sketch from tracing paper to the support. The support may be a canvas, cardboard, T-shirt, wood or metal (primed), to name but a few.

Folding sticks used to be made of bone, but these days they are made of hard plastic and are therefore very cheap (for transferring the sketch see page 59, Transfer method).

Propelling pencil

I prefer propelling pencils to normal pencils for sketching because their strokes are always a uniform width so there is no need for constant resharpening. I have found 0.5mm HB lead ideal. It deposits just the right amount of graphite, i.e. no more than is absolutely necessary, as the transferred sketch has to disappear as fully as possible into the illustration later on.

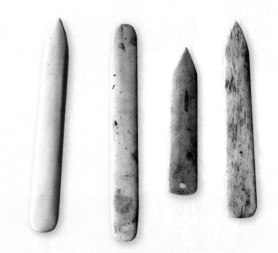

Folding sticks made of hard plastic (first from left) and different shaped ones made of bone.

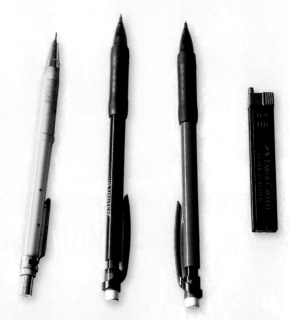

Drawing with propelling pencils requires a degree of skill and sensitivity to prevent the leads from breaking off prematurely.

Pointed-blade scalpel

Scalpels are fine knives with a blade that tapers to a point. They are used to cut cardboard, masking film, stencils and other similar materials. There is a wide range of holders for the blades, which are interchangeable. Depending on type, these knives may also be sold as stencil knives or art knives.

Do not use them for scraping, as the pointed blade will tear the paper to a greater or lesser extent.

Rounded-blade scalpel for scraping

Only scalpels with rounded blades are suitable for scraping the paint, in order to create hair, highlights or other textures. With a bit of practice you can create any desired effect without damaging the support, such as paper or cardboard.

With a little experience, you can sharpen your own blunt blades several times. Working with these tools requires a lot of concentration and care, so as to avoid either injuring yourself or damaging your artwork.

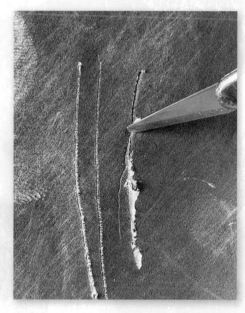

Scratching at the paint with a pointed blade leads to damage.

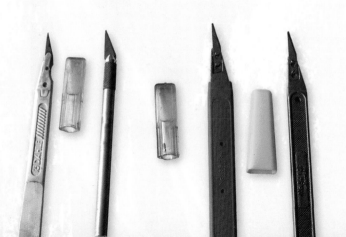

Various scalpels for cutting purposes.

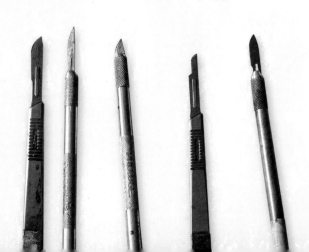

Rounded-blade scalpels are suitable for scraping paint.

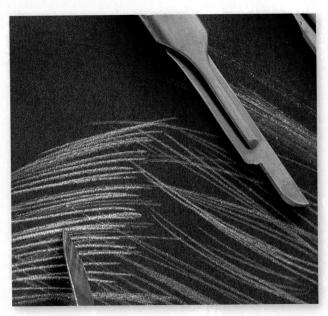

The results of scraping paint with a rounded blade.

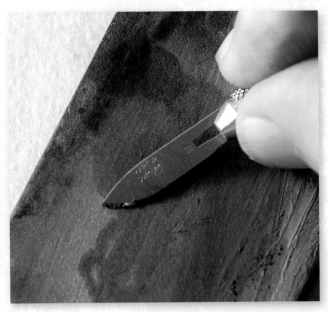

Blunt blades can be resharpened several times using a very fine sharpening stone (also known as a 'whetstone' or 'hone').

Warning!

The blades are sharp so keep these knives out of the reach of children!

Erasing knife

This is a multipurpose tool with a solid plastic handle. Properly sharpened, it is suitable for making very fine corrections, for scraping and cutting, and for lifting and peeling away masking film.

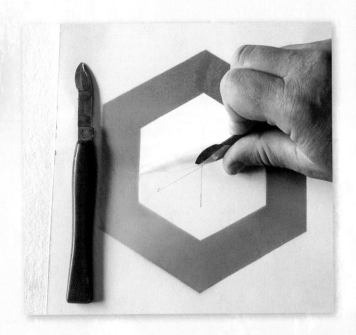

Eraser pencil

Eraser pencils are particularly suitable for creating fine textures such as hair or the pores in skin. Erasing can only be performed once the paint is dry. These pencils are available in various densities – I prefer harder cores.

Electric eraser

Electric erasers also come in different forms and with rotating eraser tips of different densities. They are designed for particularly fine corrections, which have to be performed with great precision. For instance, they can be used to create highlights in dry paint. To be able to work as accurately as possible, the eraser tip has to be repeatedly sharpened.

To obtain an electric eraser tip suitable for accurate work, I have lined two small cardboard drawers with different grades of sandpaper. With the eraser running, I hold the tip obliquely against the sandpaper to sharpen it.

Eraser pencils are available in various densities.

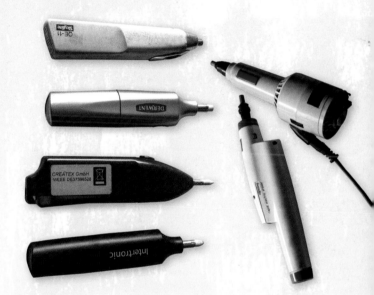

Various makes of battery-powered electric eraser. Once the eraser tip has been used up, I insert the exposed rubber from an eraser pencil.

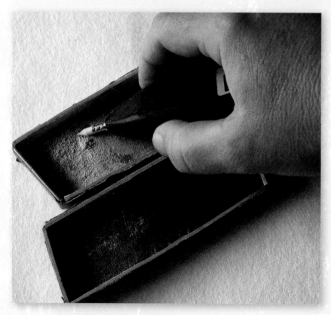

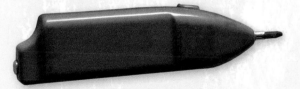

Battery-operated electric eraser fitted with the core from a coloured pencil. The rotating tip produces very dark dots and lines.

Rubber eraser

Erasers made of natural rubber are very effective although conventional rubber erasers, used correctly, can also work. A generic rubber eraser will have a hard end and a soft end; the hard end works more quickly through paint, while the soft end is gentler and will take longer.

Paintbrushes

Different tasks need paintbrushes of all different shapes and sizes. I recommend soft, sable watercolour brushes, as well as small flat brushes with short bristles.

Bristle brushes are excellent for applying pasty tube paints, but they are not ideal for airbrushing.

I use tapering brushes for mixing paints and for fine to medium lines and textures.

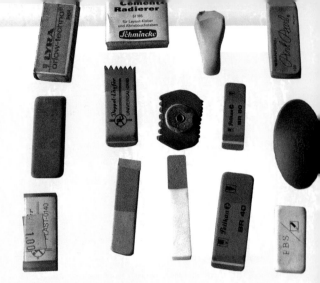

A collection of rubber erasers.

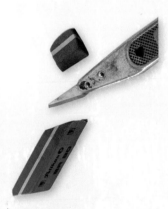

I have used my scalpel to cut through one rubber eraser to provide a sharp eraser edge.

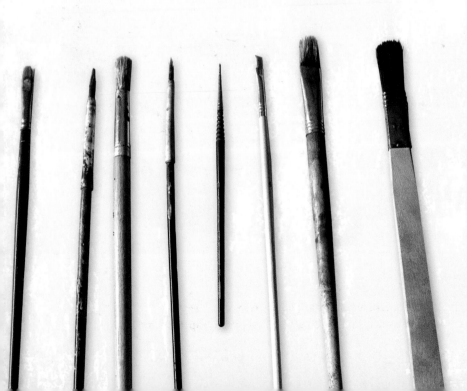

My brush collection contains both pointed, soft-hair watercolour brushes and flat bristle brushes of various shapes.

Compressor for the airbrush

Equipping yourself for airbrushing is admittedly not cheap. But, if you have the talent, airbrushing makes it simple to create incredible works of art. Having said that, I am quite certain that even after thirty years' working with airbrushing, I am a long way from having reached the technical and artistic limits of the medium.

I would recommend a compressor that has both a pressure regulator and a water trap. The pressure regulator adjusts the compressed air to the pressure you want to work with, while the water trap ensures that any condensation which collects in the pressure tank can be drained away. This has to be done regularly and, in better compressors, there is a drain screw at the bottom.

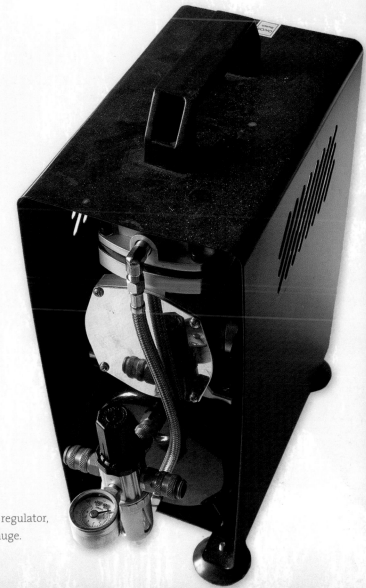

Compressor with pressure regulator, water trap and pressure gauge.

Handy tip!

If you want to take airbrushing seriously, it's worth investing in a better quality compressor with a good pressure regulator, water trap and drain screw.

The airbrush

The airbrush, also known as an 'airbrush gun' or 'airbrush spray gun', is the cornerstone for airbrushing art.

Never buy 'beginners' kits' from toy departments or craft fairs. Any pleasure you do get from them will be short-lived as poor quality tools will quickly erode your enthusiasm. There are three types of equipment you can buy – cheap, better and better still. Alternatively, you can get clued up with a book like this, pay attention to quality and find good advice from specialist dealers.

A 'dual-action airbrush' is best since the quantities of air and paint can be controlled independently of one another (see page 30, How gravity feed works).

Gravity feed airbrush

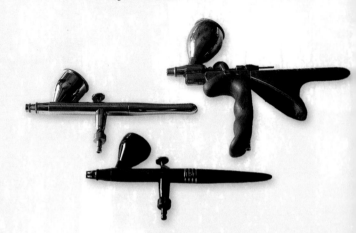

Three different gravity feed airbrushes (see page 30 to find out how they work).

Suction feed airbrush

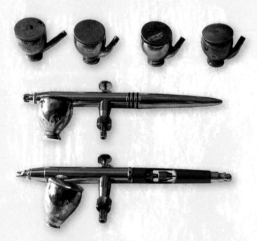

Suction feed airbrushes (see page 30 to find out how they work).

Connecting hose and couplers

The hose and coupler connect the airbrush to the compressor.

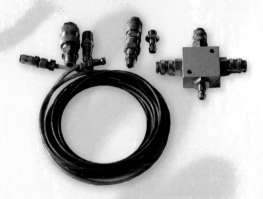

Connecting hose with various couplers.

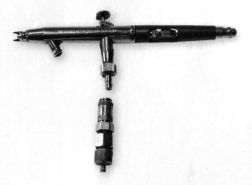

The mini coupler connects the airbrush to the hose.

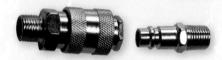

This coupler system is mainly used for vehicle painting.

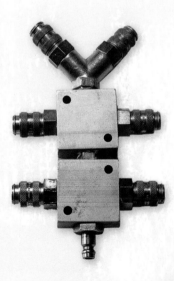

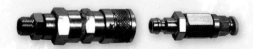

This coupler is widely used in airbrushing and connects the hose to the compressor.

Thanks to the six-way splitter, six airbrushes can be connected to a single compressor outlet port.

Pressure regulator and water trap

As already mentioned, a good compressor should have a pressure regulator with a water trap. The water trap removes the condensation that collects over time in the pressure tank. Using the pressure regulator, you can tailor the compressed air pressure to the size of the airbrush and its nozzle cross-section.

A larger nozzle cross-section of 0.5 to 1.5mm is used for coarser, large-area work, which needs a pressure of 3 to 5 bar. A cross-section of 0.2 to 0.4mm and a pressure of 1.5 to 3 bar are sufficient for finer, detailed work.

Airbrush holders

When working professionally, it's vital to keep your various airbrushes organised and ready to hand. Various solutions with clamps are commercially available.

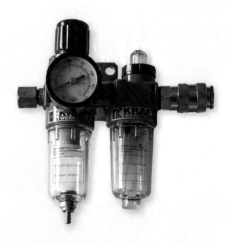

Pressure regulator for controlling the strength of the compressed air. Condensation, which can be contaminated with oil, collects in the water trap. The transparent container allows regular monitoring, while the screw allows rapid draining of the condensation.

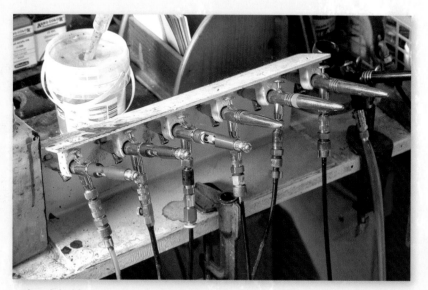

Airbrush holders, DIY. I made this by fastening cable clamps to the underside of a bar.

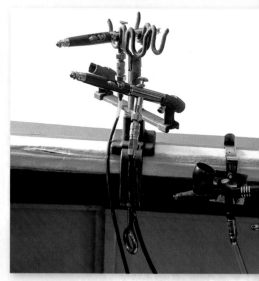

Three types of airbrush holders from specialist dealers.

Other bits and pieces

Water bottle, cup with eyedropper, suction feed bottle

The water bottle contains distilled water for thinning the paints. When working, the necessary amount is transferred into the cup from where it is drawn up into the eyedropper. Using the eyedropper allows very fine addition of the paint as thinning can be performed drop by drop.

Adhesive tape

Adhesive tape is indispensable for accurate working, for example when transferring sketches the sheets must be fixed properly in place.

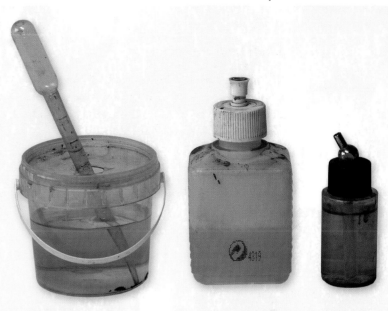

Glass bottle containing distilled water, cup with eyedropper for fine addition during paint thinning and a suction feed bottle containing water for cleaning between colour changes (only for suction feed system).

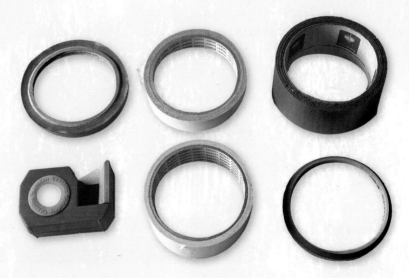

Various types and widths of adhesive tapes for all kinds of uses. I use them for masking and fixing.

Crumb brush

If you're using my erasing technique (more about this from page 54 onwards, Drawing with an airbrush), a crumb brush is essential. This is because erasing constantly produces crumbs of rubber, which must be removed with the crumb brush on an ongoing basis so that they don't make dirty marks on the paper.

Get used to only using the brush and not your hand because there's always a risk of your hand making the support unusable with grease, sweat, paint or other dirt which results in blemishes and textures that cannot be removed.

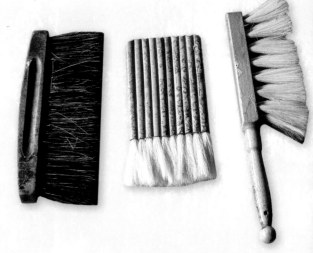

Crumb brushes are ideal for cleanly wiping erasing crumbs off the support.

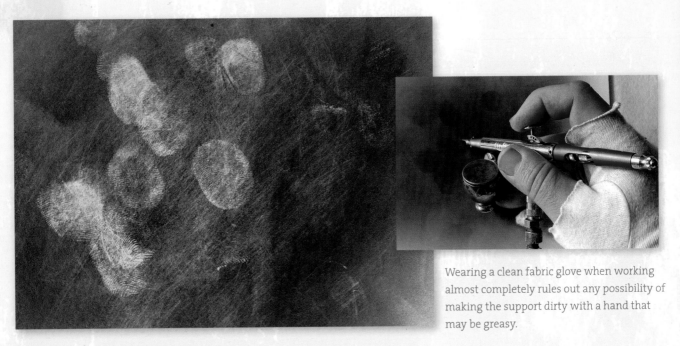

Blemishes on the support due to a dirty hand.

Wearing a clean fabric glove when working almost completely rules out any possibility of making the support dirty with a hand that may be greasy.

Sharpeners

Use good sharpeners for pencils and coloured pencils and replace them immediately if the lead breaks off in the sharpener after a few turns. It is, however, possible that the leads are breaking because they have already been broken, perhaps by having fallen off the table repeatedly. It makes sense to use an electric sharpener if you are working with a lot of pencils.

Simple sharpener and two electric sharpeners.

Just cover the support with a sheet of paper to avoid making it dirty.

The airbrush – how it works

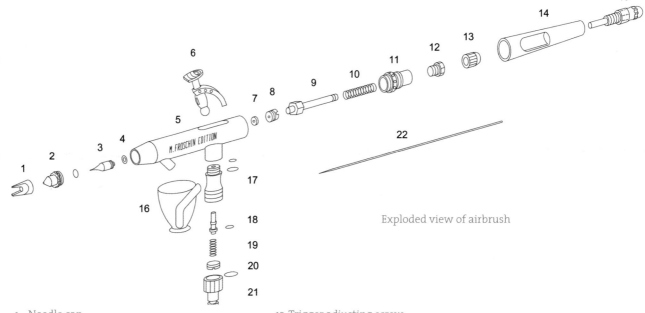

Exploded view of airbrush

1 Needle cap	12 Trigger adjusting screw
2 Air cap	13 Needle securing nut
3 Nozzle	14 Handle
4 Nozzle seal	15 Quick-Fix with dial
5 Body	16 Cup
6 Trigger unit	17 Valve body
7 Needle packing	18 Valve
8 Needle packing screw	19 Valve spring
9 Needle chuck	20 Valve closure
10 Needle spring	21 Connecting nipple
11 Guide	22 Needle

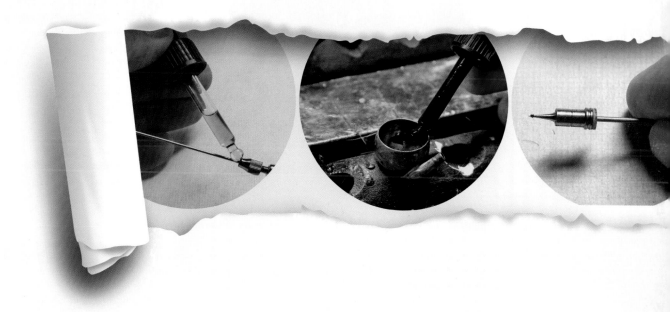

Airbrush systems

Opinions are divided about airbrush systems, based on the differences between gravity and suction feed. I really only work with suction feed airbrushes, but I will look at the strengths and weaknesses of both systems here.

How gravity feed works

With gravity feed, the paint container sits on the top of the airbrush, and the paint flows through gravity alone into the nozzle, which is opened by retracting the needle. The paint is sucked out and sprayed by the vacuum upstream of the nozzle. The air nozzle is opened when the trigger is pressed downwards. However, the paint doesn't flow until the trigger has been pressed one to two millimetres backwards.

How suction feed works

With suction feed, the paint container is plugged or screwed onto the side or bottom, depending on the manufacturer.

With this system, the paint is only sucked in or up and sprayed by the nozzle vacuum. The resultant picture is the same with either system.

How the two systems compare

What are the advantages and disadvantages of the two systems?

I can really only speak from my own experience. In over thirty years of working with airbrushes, no one has managed to convince me of the advantages of gravity feed.

Many hundreds of pupils who arrived at my classes with gravity feed airbrushes, without exception, changed over to suction feed once they had seen its advantages for themselves. This book is a practical beginner's course for suction feed.

The big disadvantage of gravity feed is the time spent cleaning the airbrush after every colour change. You actually spend more time on cleaning than working on the picture itself.

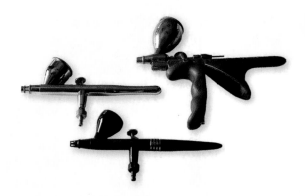

Various gravity feed airbrushes.

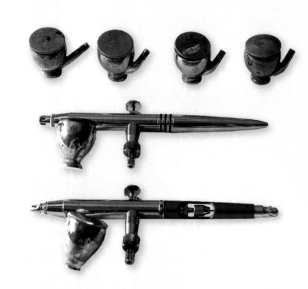

Two suction feed airbrushes and four suction feed cups for different colours for quick colour changing.

The suction feed system is simply quicker to use. The paint is placed in small cups and plugged onto the bottom of the airbrush. To change colour these just have to be changed over. Of course, this system only makes sense if you work with several cups (I would recommend six or more cups).

This is probably the reason why more than 90% of airbrushers don't use suction feed: it is simply more expensive to buy. Buying an extra six or more suction feed cups makes the system roughly twice the price of the gravity feed system. This no doubt puts most first-time buyers off, without them realising what they are missing out on.

It is also the case that many people selling airbrush accessories don't point out these advantages, because they often don't have enough knowledge or training, unless they are themselves airbrushers.

If I need more colours for an object than I have cups, for example, then of course I still have to change colours. To do this, I remove the cup I was just using, spray the airbrush until it's empty, fill up with the new colour, spray until the paint comes through and carry on. This only works, however, with related colour shades such as related skin tones.

To change between very different colours, for example from black to yellow, I have to clean the airbrush with water in between. However, even this is quicker than with gravity feed and is done in just a few seconds.

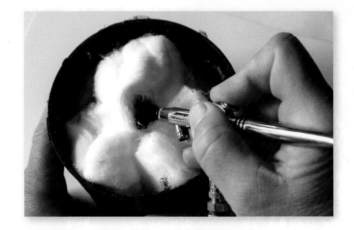

Cleaning the suction feed system between colours. For related colours I have to remove the cup, spray the residual paint onto a wad of cotton wool, plug on the cup containing the other colour and then spray until the new colour comes through. For changing between very different colours, clean the paint cup with water in between colour changes.

Maintenance cleaning

Taking the airbrush apart

For an airbrush to work with as little trouble as possible, you need to familiarise yourself with servicing and cleaning procedures. An airbrush is a very sensitive tool and regular servicing at the end of each working day is the only way to ensure that you will be able to continue to enjoy using it for years to come.

There is not one airbrush in my collection that is not fully functional, and I'm talking about equipment which has notched up twenty-five years or more of service. I've just had to replace worn parts such as nozzles, needles and sealing rings from time to time.

The following step-by-step pictures show I am a right-handed airbrusher; a left-handed person would work the other way round. The airbrush being taken apart and cleaned by me.

This operation can sound a bit complicated at first, but once you've developed a certain routine, the airbrush can be ready to use again in just two to three minutes.

I always perform this maintenance cleaning at the end of the working day. During work, for example when changing colour, it is sufficient, as described, to spray the airbrush until it's empty and briefly clean it with water.

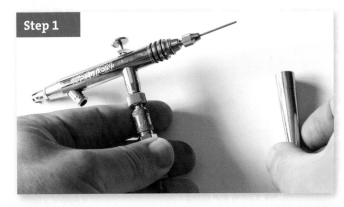

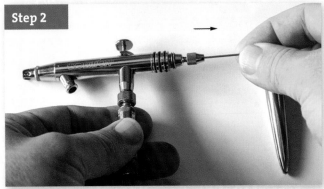

Step 1
First remove the end piece, the rear cap.

Step 2
Unscrew the knurled nut.
You need to do this in order to be able to draw the needle 2 to 3cm (¾ x 1¼in) back to outside the nozzle. (The needle's job is, by changing position, to adjust the nozzle cross-section and therefore the diameter of the spray jet.)

Step 3

Unscrew the nozzle cap.

Hold the airbrush in the left hand by the mini coupler if you're right-handed (reverse this if you're left-handed) and turn it 180 degrees to the left. When unscrewing the nozzle cap with the nozzle inside it, pay attention to the white sealing ring on the back. If you lose this, the airbrush will no longer function. The picture shows this procedure with the Harder & Steenbeck Evolution airbrush. The procedure is just the same for the Infinity, Meinrad M. Froschin Edition but does not apply to airbrushes with screw-in and plug-in nozzles made by other manufacturers.

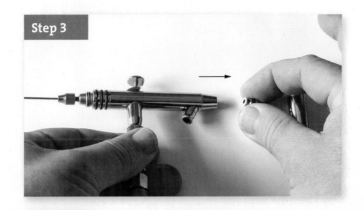

Step 4

Push the needle out.

Now push the needle two thirds of the way into the airbrush. The paint still stuck to the needle is easy to see. Always do it this way – never pull the needle backwards out of the airbrush, as people often do. Why? This is an easy question to answer: if the needle is pulled back, the paint which is stuck to it will be drawn inside and get stuck, creating a real problem. Then the airbrush will probably have to be taken completely apart and cleaned in an ultrasound bath. Why do that when it's so easy to avoid?

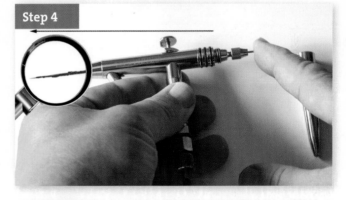

Step 5

Clean the needle.

To clean the needle, grip it with a cloth and keep pushing it forwards while cleaning it, until it is shiny and no paint is left on it.

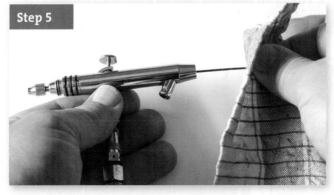

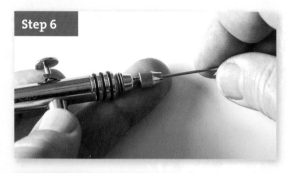

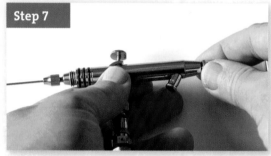

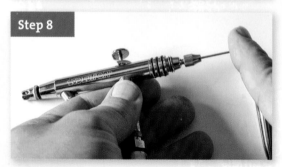

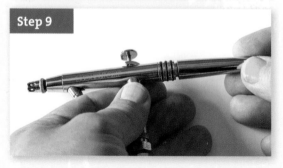

Step 6

Reverse the sequence of steps to re-assemble.

Carefully insert the needle from the back. To assist in this, first place the needle on your left middle finger and then push it two thirds of the way into the knurled nut. It's good to be able to feel as well as see what you are doing. The needle has a very sensitive tip, which is very easily damaged if not handled properly, in which case it will have to be replaced.

Step 7

Screw in the nozzle cap with nozzle and sealing ring.

Check while doing so whether the sealing ring (not a part of all models) is seated on the nozzle, otherwise the airbrush cannot be used.

Step 8

Push the needle forwards and right in.

It is as far as it will go when you feel a slight resistance. Screw the knurled nut on tightly.

Step 9

Finally, put the end piece, the rear cap, back on.

Cleaning while working

The first time you pick up an airbrush, knowing how to handle the trigger correctly is absolutely fundamental. This trigger controls both the air volume and the amount of paint that is sprayed. Perfecting how you handle the trigger is the most important task you will face as an airbrusher. Smooth operation requires flawless paint feed. Nonetheless, problems may arise if the guide needle becomes stiff and obstructs the nozzle. This problem can be minimised by thinning the paint. Practise this repeatedly and do not carry on through the book until you have really mastered this step.

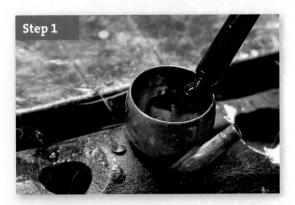

Preparatory work: Filling the airbrush with paint

Place a few drops of paint in a paint cup. Add the same amount of distilled water and stir the two together with a paintbrush. Using distilled water means that the blended paints can be used for several days. Most paints are very concentrated and always need to be thinned to make them sprayable. If used unthinned, the paint very quickly gets stuck in the nozzle and on the needle. Such clogging up restricts free movement, something which is almost impossible to correct while airbrushing. Highly thinned paint does mean that you have to spray a lot of coats to reach the desired depth, but it is easy to correct irregularities such as undesired cloudiness.

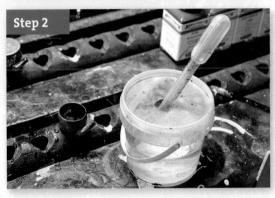

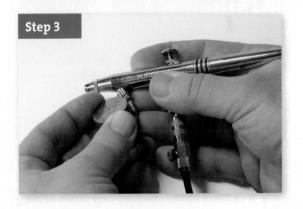

Step 1
Use an eyedropper to place the paint in the cup.

Step 2
Add distilled water in the same way.

Step 3
Plug the slightly conical stem of the paint cup onto the airbrush. Push the cup backwards with gentle force so it clips into place. Check that it is firmly attached to ensure it doesn't fall off during airbrushing.

Trigger function

Mastering this trigger, which, as you will remember, controls the position of the needle for paint feed, is half the battle in airbrushing. Be sure to practise until the process is completely automatic. It's like driving a car: until you can change gears in your sleep, you can't make any further progress.

In a dual action airbrush, first, the air nozzle is opened when the trigger is pressed down. Pulling the trigger back then opens the paint nozzle. You can press the trigger right down: there's no need to worry about too much air coming out via the nozzle. On the other hand, the trigger should only be pressed backwards by no more than 1 to 2 millimetres. This range delivers a suitable paint feed for over 90% of all airbrush work.

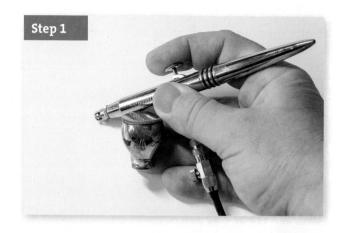
Step 1

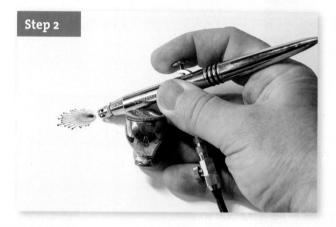
Step 2

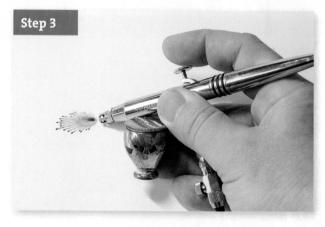
Step 3

Step 1
Pressing the trigger down.
The paint cup has been correctly inserted and is secure. Now you need to master the trigger! First of all, press it right down.

Step 2
Pulling the trigger back.
In this position the trigger is drawn back 1 to 2 millimetres and spraying begins.

Step 3
Releasing the trigger.
This automatically closes the nozzle and terminates the spraying process.

Troubleshooting by cleaning during operation

If the trigger gets difficult to move, this is generally because paint deposits in the front part of the airbrush are making it very difficult to move the control needle. This can be remedied by cleaning the needle guide.

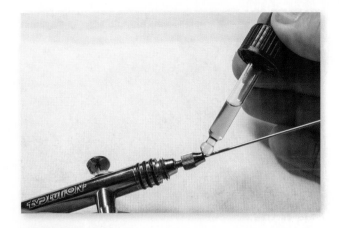

Loosening up the needle.

To solve the problem of a needle that is difficult to move, start with steps 1 and 2 of 'Taking the airbrush apart' (see page 32). Draw the needle a few centimetres back and remove the nozzle and nozzle head. Apply one to two drops of a specialised airbrush cleaning solution to the drawn-out needle, and then push the needle forwards a few times, turning it as it goes. The solution will soften the dried-on paint, which can now be pushed forwards out of the airbrush with the needle. Wipe the needle clean and put everything back together.

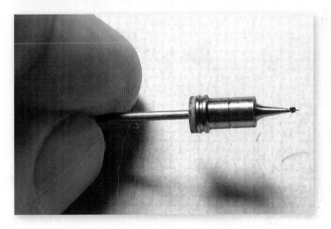

Dirty or clogged nozzles.

This is a problem you will face repeatedly, black-and-white pigments being particularly problematic.

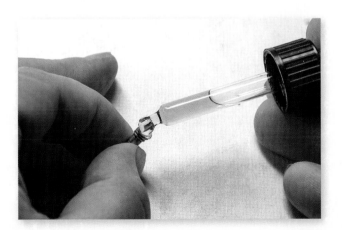

Cleaning a clogged nozzle.

This is best done with a few drops of a specialised airbrush cleaning solution. Then insert the needle again, turning as you push to expel the softened paint residues. Do this very carefully and without exerting much pressure, otherwise the nozzle tip could be damaged or even cracked.

First exercise: Lines and dots

This first exercise is just meant to teach you to operate the trigger correctly. It is best to begin airbrushing with simple lines and dots. That may sound simple, but it will take you some time to master this basic technique.

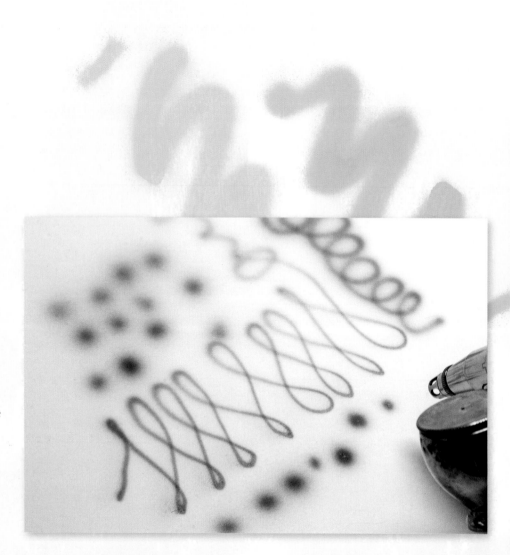

Developing a feeling for trigger action.

First of all, spray some lines and some dots of different sizes, as in the picture. Hold the airbrush at an angle of around 45 degrees. To produce a dot, press the trigger right down, pull it a millimetre back and then let go again straight away. The trigger will then jump automatically back into its starting position and close the air and paint nozzle. For lines and larger areas just keep the trigger pressed for longer.

Distance from the support.
This is critical for the spray
pattern. The closer you are to
the support, the darker and
more clearly defined is the
applied paint, while the farther
you are from the support the
more diffuse and lighter the
applied paint becomes.

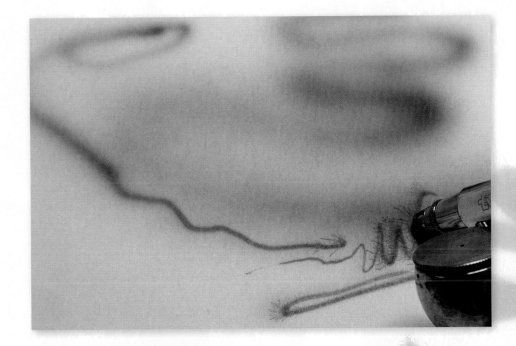

'Spiders'.
These are the result of spraying
a large amount of paint in one
place, so it can't dry off quickly
enough. The air then blows the
still wet paint around into a
'spider' shape. This is sure to
happen a few times when you
first start and practice will help
you to stop doing it!

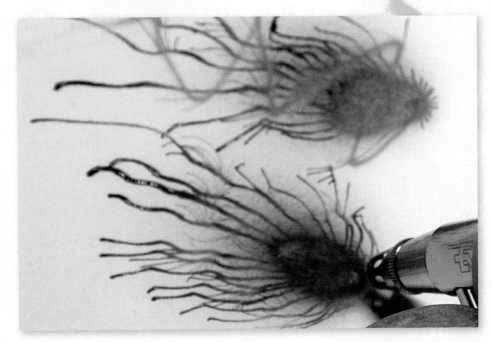

Paint in airbrushing

Paint plays a central role in the art of airbrushing. The particular way in which the paint is applied results in some special features that you absolutely must be aware of if your efforts are to be crowned with success.

The most fundamental factors are the type of paint used (whether it is opaque or transparent) and how it is applied. I am mainly thinking here about the way in which colour gradations are formed because they define the appearance of this style of art in which extremely fine transitions can be sprayed with wonderful colour mixtures.

Both basic techniques, transparent and opaque, are combined here. The actual portrait was produced using a transparent combined airbrushing and erasing technique. The upper half, however, is painted opaquely, mainly using a paintbrush and sponge, becoming transparent again towards the bottom.

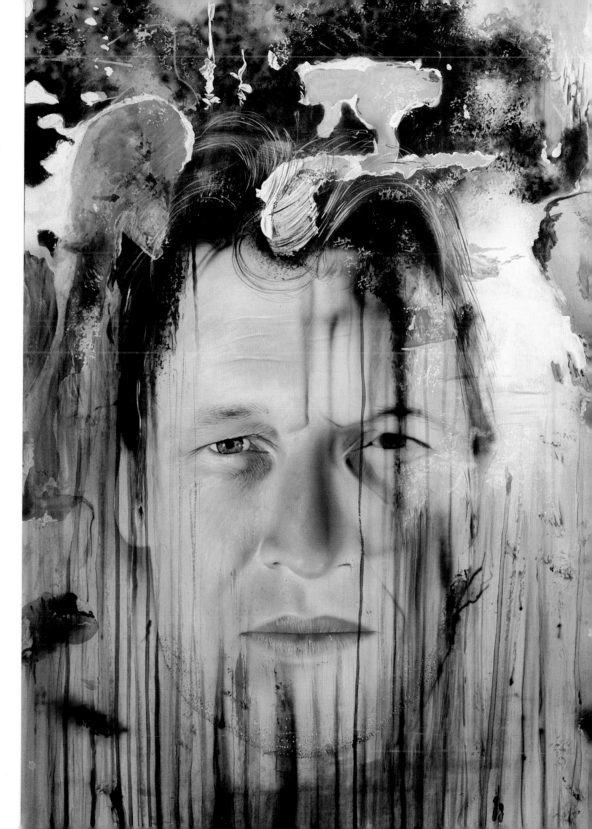

Transparent or opaque airbrushing

Two basic groups have developed among airbrush users: those who use opaque paints and those who use low-pigment paints, which are thus transparent. These two types of paint are commercially available under various names.

What are the differences between working with these paints and the results obtained?

Opaque airbrushing

Opaque airbrushing means that once the first coat of opaque paint has been applied, subsequent coats are no longer applied onto the untreated support (cardboard, canvas, wood, metal or whatever), but instead onto a pigmented coat of paint which has previously been applied with a brush or airbrush. Each subsequent coat of paint covers the preceding one to a greater or lesser extent and results in certain cases where the paint coat can be as much as 1 to 2 millimetres thick. It is possible to work from dark to light or from light to dark.

Transparent airbrushing

Working with transparent paints means the support is always visible, however many coats of paint you spray on. This is because the size of the particles of paint in this technique are in the nanometre range (one billionth of a metre). As a result, a new coat does not mask the preceding one but instead results in delicate colour mixing.

Result when applying opaque paints.

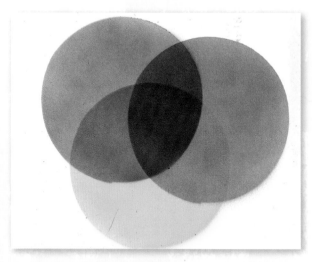
Result when applying low-pigment, transparent paints. Delicate colour mixing is obtained.

Transparent and opaque in one picture

Opaque and transparent paints can also be infinitely variably combined with one another. I know that many renowned artists who work with opaque paints change over to transparent paints to add the final, detailed touches to a work.

But do not forget that all the works in this book were obtained by the combined airbrushing and erasing technique using

transparent paints. There is more about this in the exercises starting on page 54 (Drawing with an airbrush).

Find out which technique works best for you – I can't go through the trial-and-error process for you. However, if you are able to reproduce the exercises in this book unchanged, then the decision to use transparent paints will have been taken for you.

The entire picture was produced using opaque paints, the palm tree was not airbrushed, but painted.

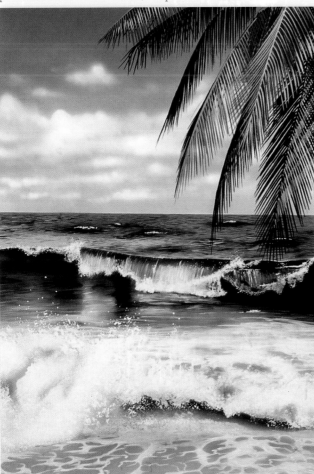

Combined technique: transparent technique was used for the sky, waves and beach, while the palm tree was again painted with a brush using opaque paint.

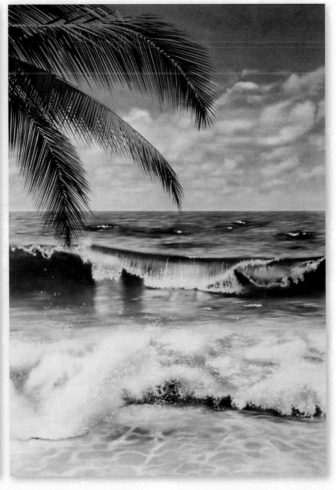

Principles of colour theory – colour gradations

As I have already mentioned, colour gradations, whether in single or multiple colours, are a distinctive feature of airbrushing. I will therefore start by telling you something about a single-colour gradation before moving on to two-colour gradations and finishing with a colour wheel with complementary colour pairs. As you spray the colour gradations, you will also be learning essential principles of colour mixing.

Do these exercises on 250gsm (8.8oz) A4 illustration board. Cut out rectangular stencils of any desired size. The stencil material is Pellon for the gradations, masking film for the colour wheel and cardboard for the complementary colour pairs. The primary colour for the first exercise is cyan.

Purpose of the weights.
The rectangular stencil is held down on the left-hand side with weights. I made these myself, but heavy metal nuts will do the same job. They stop the stencil from lifting up and allowing paint to get underneath during airbrushing.

Correct spraying distance.
Just to be on the safe side, you will start off by spraying a gradation at a relatively large distance from the support (around 20 to 25cm/7¾ to 9¾in) to ensure that the colour gradation from dark to light is as even as possible.

Just a quick reminder about the sequence of spraying: first, press the trigger downwards to open the air nozzle. Now pull the trigger 1 to 2 millimetres (about ¹⁄₁₆ of an inch) backwards, so opening the paint nozzle and causing paint to be sprayed. The supply of paint is shut off when you release the trigger.

Single-colour gradation

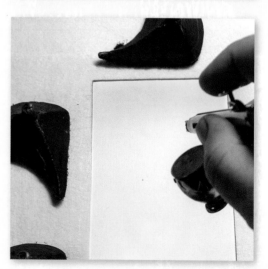

Incorrect spraying.
Never try to create gradation in one go. When using a stencil, it is of course possible just to reverse direction and continue airbrushing, but you shouldn't do it. Why? When you're working on an illustration, you won't often have a stencil on which you can reverse direction and continue airbrushing.

Poor result.
Incorrectly sprayed, the gradation has stripes. If you aren't happy with the result, just try again from the beginning on a new sheet.

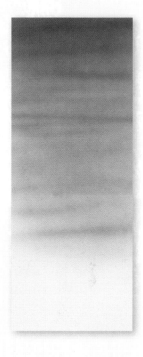

Stop and start is better.
To spray properly, begin on the right-hand side of the stencil. Move leftwards with a steady hand and stop spraying on the stencil on the left by releasing the trigger. Now do the same, moving back rightwards and repeat again from the right to the left etc.

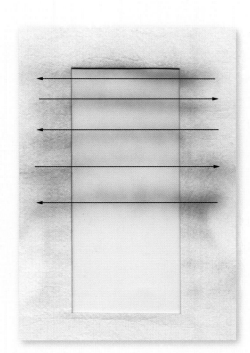

Perfectly sprayed cyan gradation.
An even area without transitions is obtained.

Two-colour gradation

These three gradations were produced from the colours cyan, magenta and yellow. Why these colours specifically? Because they are the primary colours from which no further colour shade can be subtracted. Most magazines and books are printed using these three primary colours together with black and the white of the paper. Exceptions include art prints with special colours such as gold, silver and other colour shades. All other red, yellow or blue secondary colours include at least one further colour.

An infinite number of different colour shades may thus be printed or airbrushed using the three primary colours plus black and the white of the paper support.

The same naturally also applies to airbrushing. In other words I also created the images in this book using the three primary colours together with black and the white of the paper. If the support is not white, a white background must be applied before using transparent paint.

I have, however, sometimes used special paints in some images. These are Schmincke's Aero-Color Brilliant Green and Ultramarine paints. The luminosity and purity of the pigment blends from this manufacturer cannot be achieved simply by mixing the primary colours yellow, cyan and magenta.

Cyan and yellow gradation.

Magenta and yellow gradation.

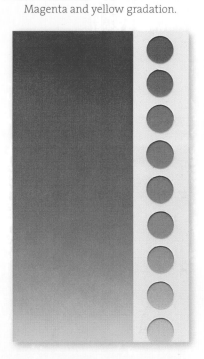

Cyan and magenta gradation.

Colour wheel gradation

The way in which all colours interact and harmonise with one another when mixed is best illustrated and practised with a hexagonal colour wheel, which can be produced using a simple piece of paper (drawing paper) for drawing the hexagon, Bristol board (the support) onto which the colour wheel will be sprayed, and self-adhesive masking film.

You can make the stencil for the regular hexagon by following the steps on the following pages.

Antoshka with magnifying glass.
The magnifying glass reveals how colours are made up in halftone printing using the primary colours yellow, magenta, cyan together with black and the white of the paper.

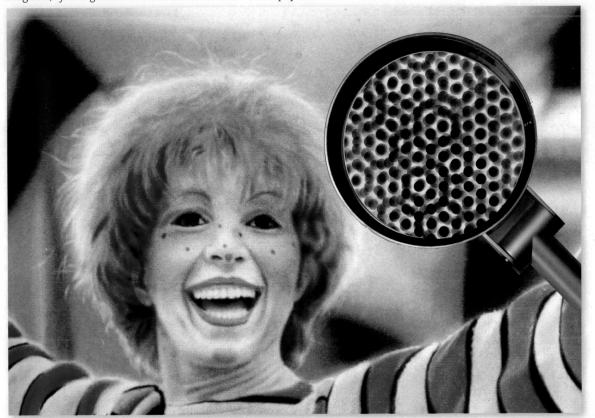

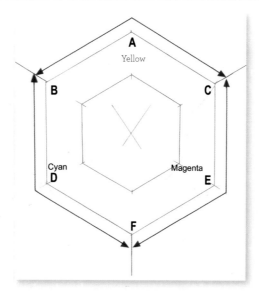

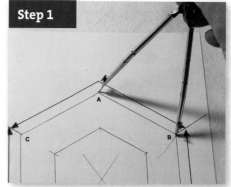

Step 1

Designing the hexagon on the drawing paper.

- Using a pair of compasses, inscribe a circle the size of the hexagon.
- Determine any desired point (indicated A on the design).
- Insert the needle of the pair of compasses at this point.
- Using the pair of compasses, which is still set to the radius of the circle, mark two further points to the left and the right on the circle (indicated B and C on the design).
- Insert the needle at B and C and repeat the above procedure to obtain points D and E.
- Repeat the procedure from point D or E to obtain point F.
- Join these six points with a line to complete the hexagon.
- Follow the same instructions for the inner hexagon.

The finished design shows where the centre for spraying each of the three primary colours will be located.

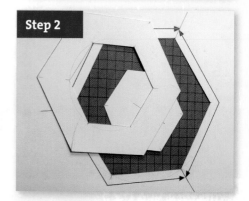

Step 2

Cutting the hexagon.

The hexagonal shape for the stencil is then cut out from the drawing paper.

Step 3

Applying the masking film onto the Bristol board.

The stencil for the colour wheel is cut from a piece of masking film from a roll that is a little larger than the Bristol board. To detach the film from the backing paper, place the film on the Bristol board and rub down firmly by hand, moving from the inside outwards. Prick any bubbles with a needle and rub the film down again.

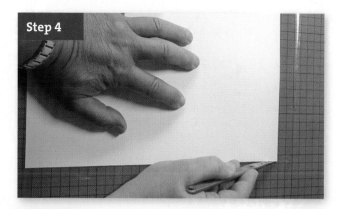

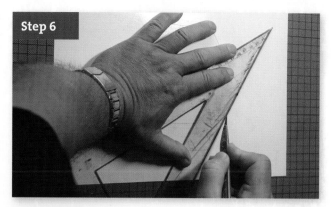

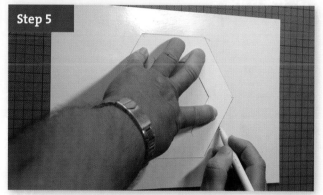

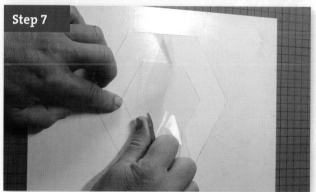

Step 4
Cutting the masking film to size on the Bristol board.
Temporarily turn over the Bristol board to trim the masking film flush to the edge using the edge of the board to guide the scalpel. Then turn the board back over again.

Step 5
Copying the hexagon onto the masking film.
The cut out hexagon shape from step 2 is placed in the middle of the masking film and held firmly in place. Using a pencil, trace around the inner and outer shapes.

Step 6
Cutting the stencil out.
Using a straight edge as a guide, cut the shape transferred onto the film with a sharp scalpel, making sure to cut only the film.

Concentrate on the tip of the scalpel and only press down gently. The soft film offers little resistance, while the underlying, harder Bristol board offers greater resistance. So, as soon as the resistance rises, stop pressing harder as the film has already been cut through. The Bristol board must remain undamaged. I would advise practising cutting only the film as it is not entirely straightforward.

Step 7
Removing the masking film.
The hexagonal shape is best removed from the film using an erasing knife as a scalpel could cause slight damage to the Bristol board. The middle of the stencil stays masked by the small hexagon.

Step 8

First paint application, primer. Following the instructions from step 1, the hexagon is divided into three zones for the primary colours yellow, magenta and cyan. Spray a light gradation from the centre of each zone towards the edge and back as a coloured primer. The airbrush should be guided in the same way as for the preceding gradations.

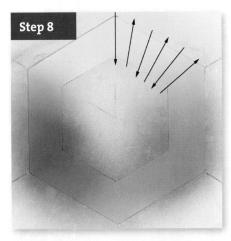

Step 9

Second paint application, yellow. The overlaps from spraying produce a light green on cyan and a light orange on magenta.

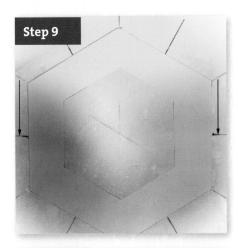

Step 10

Second paint application, magenta. After spraying, the red extends into the orange, strengthening it, while mixing with blue creates a light violet.

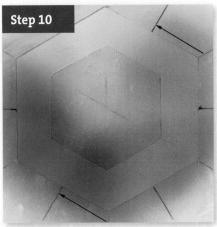

Step 11

Second paint application, cyan. The blue deepens the transition towards green, while towards the red the violet becomes more nuanced.

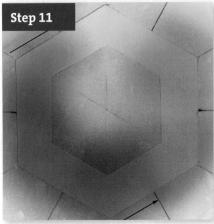

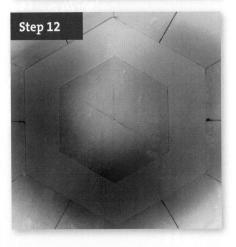

Step 12

Third application, all three colours. This is a correcting application to adjust gradations. Any blotches are eliminated.

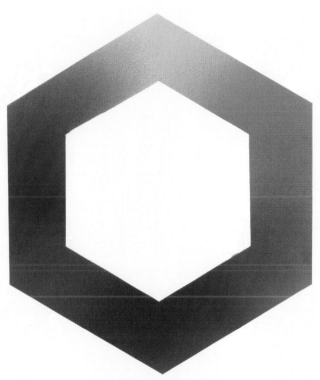

The finished image.
This is what the finished colour wheel looks like once the masking film has been removed.

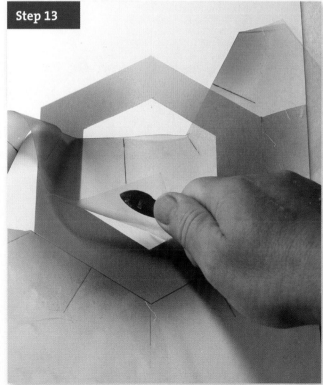

Step 13

Step 13
Peeling off the masking film.
As in step 7, the masking film is removed from the support, Bristol board, using an erasing knife.

Complementary colours

The contrasting colours located on opposite sides of the colour wheel are known as complementary colours. For instance, cyan is opposite red-orange, magenta is opposite green, and yellow is opposite violet.

When arranged in 'complementary contrast' to one another, these colours from the opposite sides of the wheel strengthen each other's effect.

If these colour pairs are mixed with one another in identical proportions, they neutralise their colours. Their effect is lost and dirty grey shades are obtained in which the original colour may nonetheless be visible if the proportions were slightly unequal.

The following examples show the optical effect of different pairs of complementary colours.

The complementary colours in isolation.
The finished colour wheel is underneath these twelve windows.
The complementary colour pairs are opposite one another.

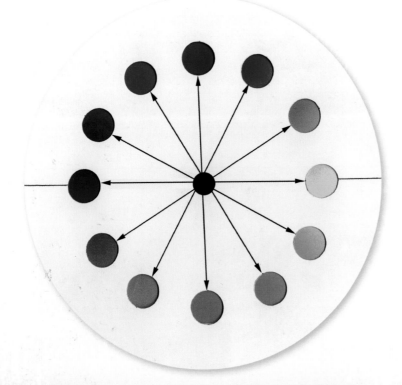

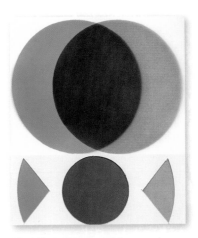

The effect of green and magenta.

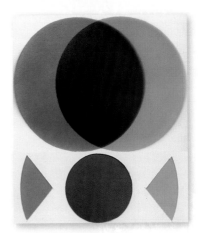

The effect of cyan and red-orange.

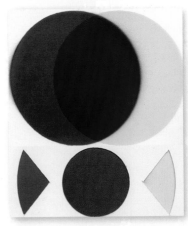

The effect of violet and yellow.

Obtaining neutral ochre.
To obtain a neutral ochre shade the proportions of green and magenta must be more or less equal. The example shows quite how quickly a colour mixed using complementary principles can change.

Obtaining brick red.
Adding more magenta results in a brick or rusty red. In this case it is the proportion of green that determines the greyness of the mixed colour.

Obtaining olive green.
Adding more green results in olive green. The proportion of magenta determines how 'dirty' the green becomes, i.e. how high the proportion of grey is.

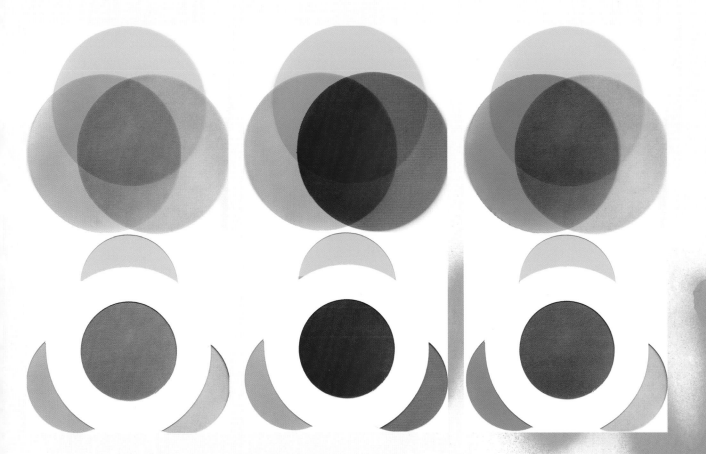

Drawing with an airbrush

By now you know about the tools I use, at least the most important ones, and how to handle an airbrush. You have also learned what additional equipment is necessary and how colours react when mixed. So now we can move on to the practical part, illustrating and drawing with an airbrush.

The next exercises will continue to concentrate on correct trigger handling, along with a further colour gradation, which will guide you through drawing and creating the illusion of a third dimension.

Illustration for the label for a
cherry-flavoured black tea.

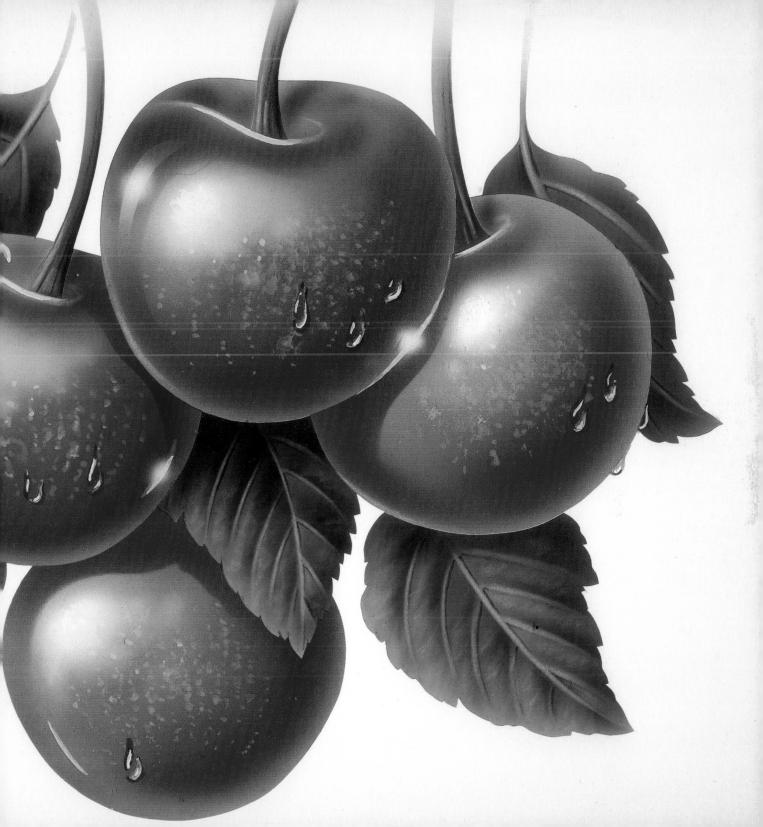

Into the third dimension...

Exercise: Sphere

To make a sphere look three-dimensional, i.e. to give it depth, you need a circular stencil of whatever diameter you fancy. Depth is obtained when natural or artificial light falls on a body from the side. It is irrelevant whether the light comes from the sun or from a lamp. The light produces a bright side and a corresponding shaded side on the body.

The quickest way of producing a circle shape is with a compass cutter. However, you can make do perfectly well with drawing a circle with a normal pair of compasses or just drawing round something circular, for example a small plate. A scalpel or other sharp tool will cut a circle out cleanly and as smoothly as possible, without turning it into a 'polygon'.

Step 1
Producing a round stencil.
Cutting the round hole in the cardboard produces two parts, which will both be used as stencils (the round cut-out will be used in Step 5). The simplest way of obtaining this shape is with a compass cutter (the picture shows two different types).

Step 2
The colours of the sphere.
The final colour of the sphere is shown on the right. The colours below show the mixing sequence. The initial colour is cyan, to which some magenta is then added. That results in the warm mixture in the middle. Then a few drops of black are added to produce the final blue on the right.

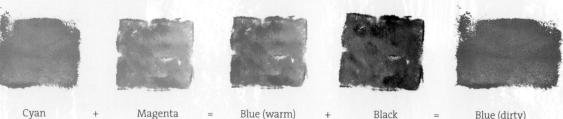

| Cyan | + | Magenta | = | Blue (warm) | + | Black | = | Blue (dirty) |

Step 3

Producing a self shadow.

To produce the self shadow, black is thinned with water in a 50:50 ratio. Then start with a circling movement, as in pencil drawing. In this example the light source is top left, so the shadow is then produced bottom right. The stencil is fixed in place using two adhesive strips at the corners, to stop it slipping. The left-hand side is weighted down to stop paint from getting under the stencil.

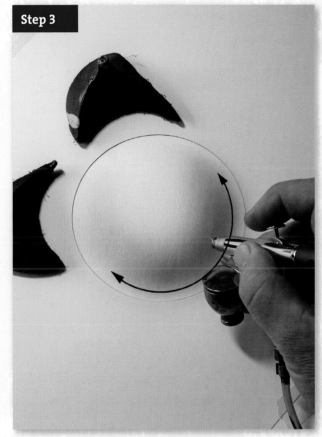

Step 3

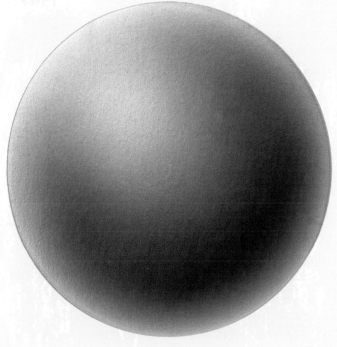

Step 4

Step 4

Transparent blue is sprayed on.

This is also done in circling movements, to emphasise the spherical shape. The black shadow is not concealed by the transparent blue; instead, it is retained and takes on a bluish hue.

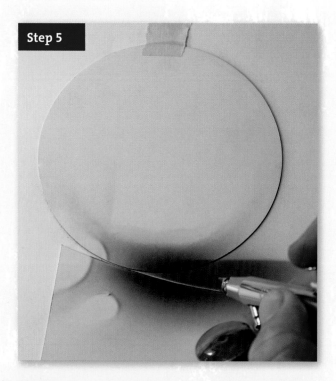

Step 5
Producing a cast shadow.
The impression of depth is increased if a cast shadow is added in thinned black. To do this, cover the sphere with the circle template (from Step 1) and shape the shadow with a general purpose stencil (see page 12).

Finished image.
Finished sphere with cast shadow.

Colouring black – the effect.
This shows how black changes when it is the first colour to be sprayed and is subsequently coloured. The transparent chromatic colours incorporate the black and change its basic colour. If, on the other hand, black is sprayed over chromatic colours, the effect is generally very dirty and sooty.

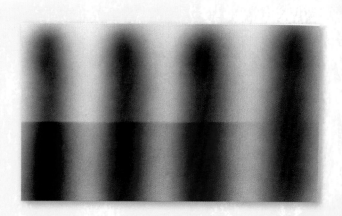

The transfer method – my transfer technique using a projector

The transfer method is how you transfer an original image onto the support. I'm not going to describe transfer techniques using halftone screens or pantographs, since these techniques are hardly ever used any more. These days artists, at least those working in photorealism, use cameras, computers, plotters and especially image projectors, such as episcopes.

An episcope operates like the projector I use, except that it stands on a table and projects the original onto the wall, like a slide projector.

For my airbrush images I always start from my own photos, which I transfer to drawing paper using a projector. I learned to appreciate this transfer method when I worked as a textile designer, and since then no one has been able to convince me of a better, more accurate transfer method. Once you're really familiar with it, you will also learn to appreciate its immense advantages.

The projector in my workshop.
My projector is fastened to the wall on an adjustable pole. The projector uses light and a mirror to project the originals down onto the Bristol board or the tracing paper. The higher the projector is raised, the more the original is enlarged.

Transferring outlines of various photos

Here you can see how the outlines of various photographs are transferred as originals and composed into an overall picture.

Please don't ask me how I come by the ideas for my pictures, as I can't really explain it. I just think of myself as a sort of antenna that receives pictures. The whys and the wherefores don't really interest me.

Example: Walking on thin ice

Component 1
Daniela acted as my model. I painted her to look like a traditional harlequin and photographed her posing as a tightrope walker.

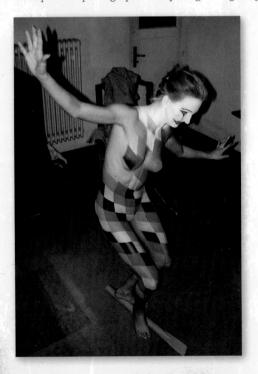

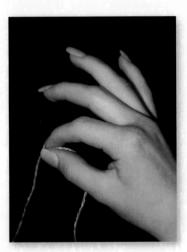

Component 2
Daniela was also the model for the elegant hand holding the thin rope.

In this airbrush picture, the thin rope symbolises speech, symbolically traversed by a tightrope walker. (Picture size 100 × 70cm or 39½ × 27½in).

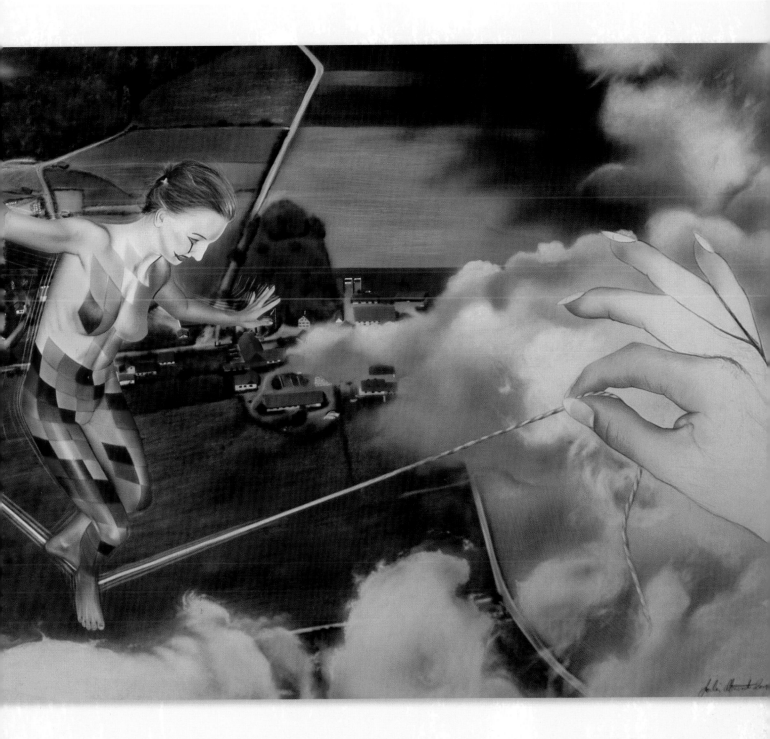

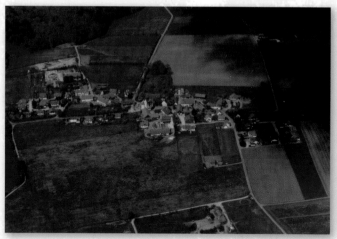

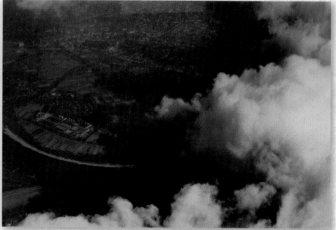

Component 3
The background: I found the village of Beyern on a sightseeing flight over Southern Germany.

Component 4
I photographed the clouds when coming in to land in the US.

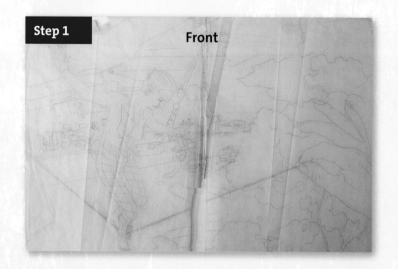

Step 1

Front

Step 1

The sketch on the front of the tracing paper.
This is a real working example that has been damaged over the years. I created it twelve years ago and I have been using it on all my courses to explain the transfer method. I produce my sketch on tracing paper using the four photographic components. For this purpose, I place the photos in the projector and move it up and down to achieve the desired size and position. Then I draw the images with a propelling pencil. The drawing produced in this way on the front of the tracing paper is the same way round as the subsequent airbrush picture.

Step 2

Front

Step 3

Step 2

The sketch on the back of the tracing paper.
Turning the tracing paper over (the word front is therefore back to front), I trace over all the lines as accurately as possible. A back-to-front version of the sketch is produced. Corrections can still be made at this point. This sounds like a lot of work, but it isn't really.

Step 3

Transferring the sketch.
The sketch is turned over again, back to the right side, positioned on the Bristol board support and taped down at the corners to stop it from slipping. Then I rub over the back-to-front sketch on the back with the folding stick, transferring it to the Bristol board.

To clarify:
The demonstration photo shows the sketch, which has been rubbed over and transferred onto the support the right way round. All this turning of the sketch over and over does sound very complicated, but once you've done it a few times it's simple and logical. As a tip, I would recommend that you write the word 'front' on the front before you get started. Then it's always clear which side is which. The advantage of this transfer method is that you are only ever working with one pencil line, namely the one from the drawing on the back. You can rub over this sketch, or individual parts of it, a dozen times and the lines will still be just the same.

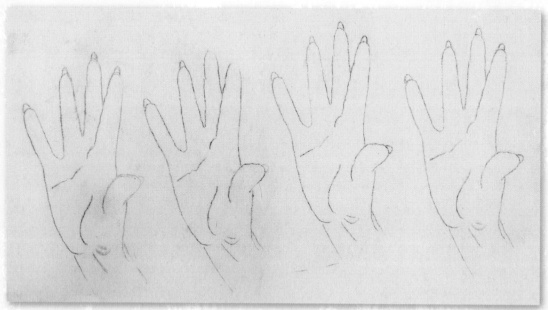

The rubbed-over hand times four. One of the advantages of this transfer method is being able to transfer identical lines several times.

Stencils for 'Walking on thin ice'.

To make stencils, you rub the corresponding part of the image onto stencil material and cut out the shape. In addition to these four stencils for Daniela's body painting, there were others for the hand, the rope, the Harlequin, the house roofs and the fields in the background. When you're working, if you find you don't have all the stencils you need, go back to the traced image and use it to transfer the corresponding part to the stencil. For this reason, you should always hold onto the sketch until you've finished the work.

Repeated outline transfer

Example: Rose picture

At the beginning of this chapter I mentioned that I learned the transfer method when working in textiles. A typical practical outcome is the following textile design, which shows very clearly how this transfer technique can be used. The repeated use of just three elements has produced a colourful picture.

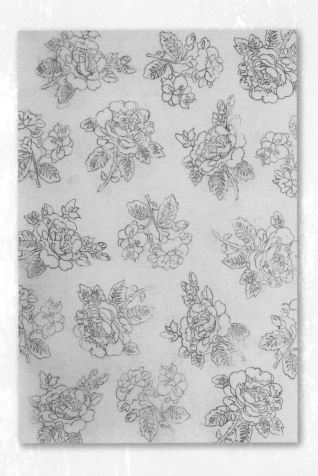

Creating the design.
A sketch like this can be drawn in just a few minutes.

The transferred design.
The three roses in the design were repeatedly moved and turned slightly and then rubbed over each time.

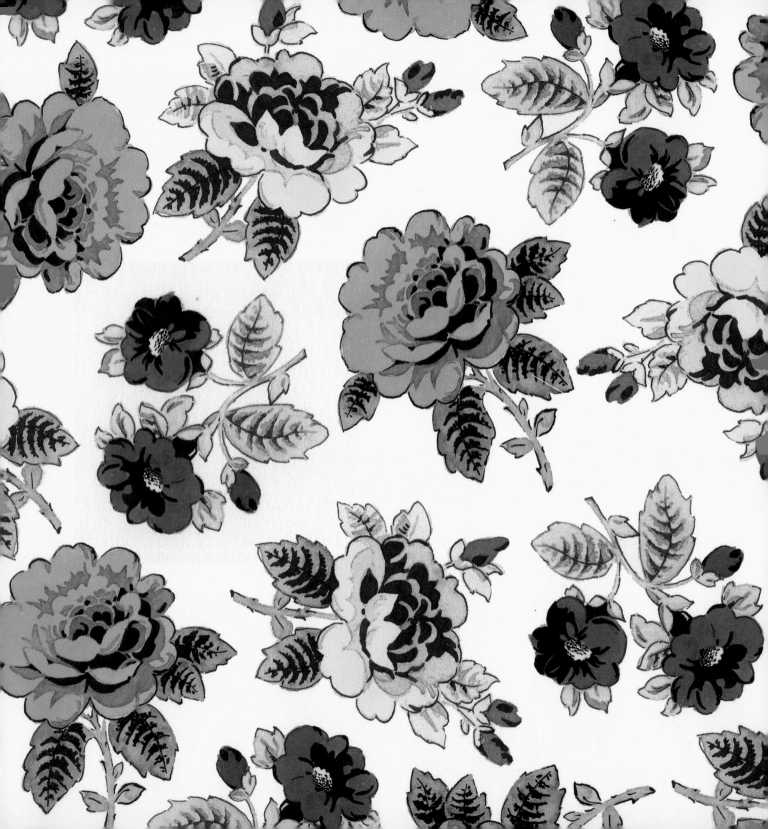

Practical erasing exercise

Example: String of beads

A string of beads is ideally suited to the reproduction of spheres in a way in which they often occur in daily life. This technique can also be used for spherical objects such as footballs, billiard balls, balloons or melons.

The original for the string of beads was taken from a jewellery catalogue, scaled to the right size and edited on the computer using Photoshop and then printed out.

The sketching and transfer procedure is repeated. As described above, you produce the tracing on the front, trace over it on the back and then transfer it to the support using the folding stick.

Step 1
Producing the sketch on tracing paper.

Step 2
Turning over the sheet of paper and tracing over the shape. Alternatively, the original for a string of beads can also be printed out back to front, which saves the step of drawing on the front. However, I shall describe the conventional procedure here again.

Colourful rose picture.
Look closely: just three different roses were sketched for this flower design.

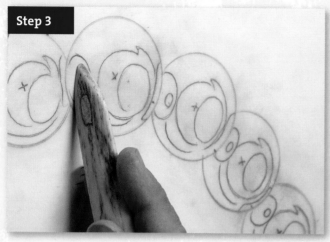

Step 3

Step 3
Using the folding stick to transfer the sketch.

Result of step 3.
The sketch has been clearly transferred.

How I devised the erasing technique

I started to use the erasing technique in airbrushing more than three decades ago. Because airbrushing involves applying paint by spraying, it doesn't penetrate into the support but instead just lies on the surface. It is therefore only very loosely attached to the substrate. This can be a major disadvantage, because the paint can be very easily damaged. It is unforgiving when it comes to dirt, fingerprints and scratches, which can be caused by the slightest carelessness.

My erasing technique, which deliberately interferes with the paint, takes advantage of this excessive sensitivity. It took me a long time to achieve my current level of expertise, but now I find there are no limits to the use of this technique when it comes to photorealistic illustrations.

Step 4

Stencils from the shapes in the sketch.
To produce the outlines of the spheres, different
shapes are needed to take account of the obscured
parts of the circle shape.

Stencil 1 is used to create the beads as
separate units. Since these partially
overlap, each bead needs its own stencil.

Stencil 2 is used to produce the
reflection of the beads in other beads.

Stencil 3 is used to cover the finished
string of beads, allowing a shadow to be
airbrushed beneath it. This produces
more depth, because the string of beads
now appears to be resting on a surface.

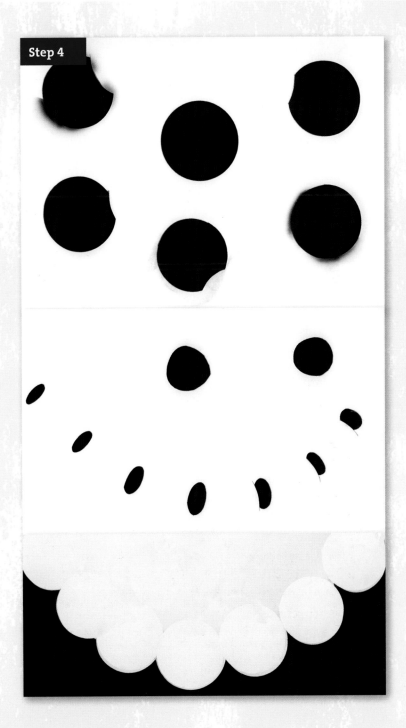

Step 4

For the colours, you can give your imagination free rein. The beads have their own intrinsic colour, but they also reflect each other and the surroundings.

This is my suggested colour scheme:

Place three to four drops each of magenta, Brilliant Green and Ultramarine into the paint cup. Mix in one to two drops of black and ten to twelve drops of water.

These quantities are just rough guidelines. Be patient but unafraid of experimenting. Small amounts of one colour can be changed just by the addition of a brush tip's worth of black or another colour. During my time as a textile designer I mixed innumerable colours, and it took me years to get it absolutely right.

The only way to learn to mix is by mixing, mixing and more mixing. You will repeatedly have to throw away failed attempts at mixing and start again from scratch. That's just how it goes. Don't be disheartened by it, think of it as an incentive. There's barely a colour I couldn't mix nowadays.

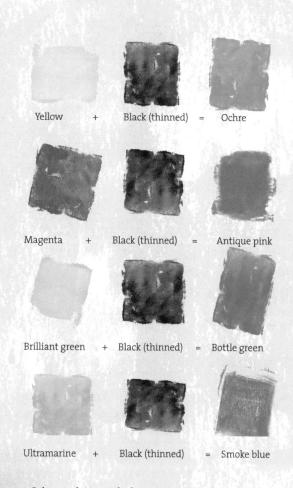

Yellow	+	Black (thinned)	=	Ochre
Magenta	+	Black (thinned)	=	Antique pink
Brilliant green	+	Black (thinned)	=	Bottle green
Ultramarine	+	Black (thinned)	=	Smoke blue

Colour palette with the mixtures for the beads.

Some good advice for working with transparent paints

- dark to light.

- background to foreground.

- fuzzy to sharp.

Step 5

First of all, the dark parts are airbrushed freehand, always going from dark to light.
Stencils are only used for the overall shape of the bead.

Step 6

Erasing back the black.
The first coat of paint is sprayed on. To be able to erase, a bit more paint than is needed must always be sprayed on, because some of it is removed again during erasing in order to produce different edges or highlights. In this case, use the red, soft end of the Pelikan BR 80 eraser.

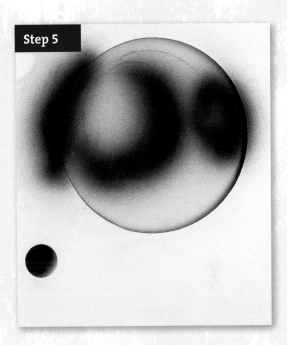

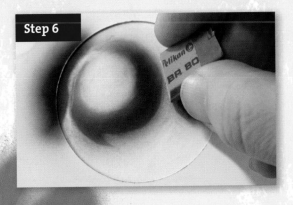

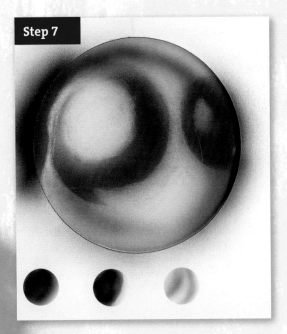

Step 7

Adding light grey.
This is mixed from black with a very large amount of water to produce some lighter effects over the entire sphere.

Step 8

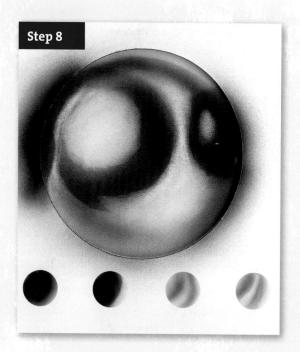

Step 9

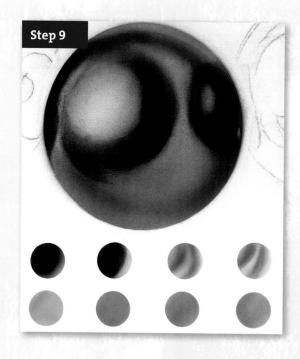

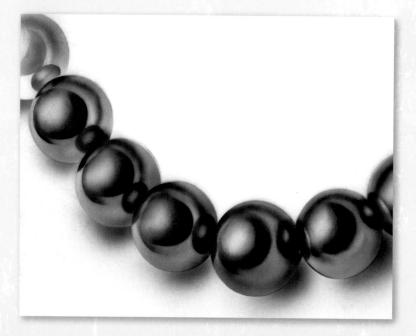

Step 8
Erasing back again.
New edges and highlights are also erased from these light areas, this time using both the soft and hard ends of the rubber eraser.

Step 9
The icing on the cake: colouring.
The bead itself is finished. Colouring with ochre, smoke blue, antique pink and bottle green adds a colourful finishing touch. All the reflections only make real sense when all the adjacent beads from the sketch in Step 1 have been airbrushed as described above.

Finished image: the finished string of beads.

Practical exercises using strong colours

I have chosen fruit and vegetables, such as peppers, apples and bananas, for the following exercises. Why?

Well, you could do the following exercises by reproducing the illustrations from this book, but it might well be better to go out and buy some fruit, photograph it yourself, transfer the photograph to your sketch and apply the described technique to these subjects. If you do this, you will learn a great deal more.

Example: Red and green pepper

The procedure for either colour of pepper is almost identical, but it is important to become familiar with certain subtleties and to develop some practical working routines by carrying out similar exercises.

Step 1
Pepper.
Your photo could look like this.

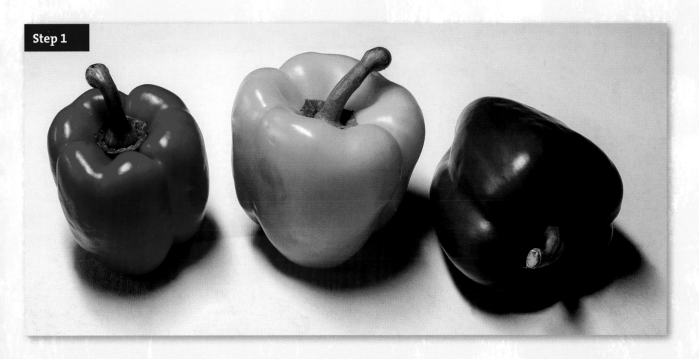

Step 1

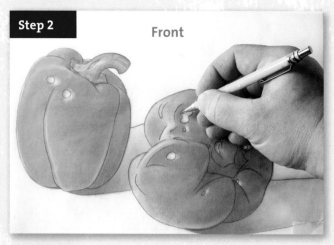

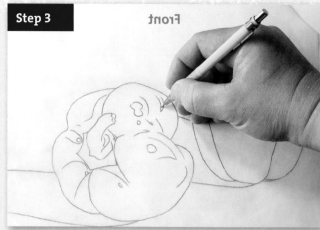

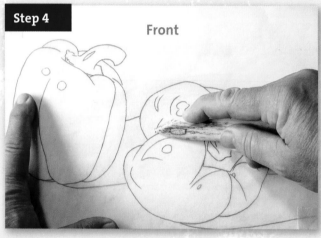

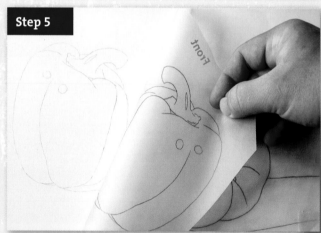

Step 2 to 5

As shown previously, the process of producing the sketch from the initial drawing to rubbing down the original.

Step 6
Stencil for the red pepper.
Rub the outlines of this pepper from the sketch onto suitable material and cut out the necessary shapes.

Step 7
Mixing the colours for the red pepper.
Magenta and yellow are the only basic colours required for the red pepper, while brilliant green, yellow and magenta are required for the olive shade of the pepper stem. Since many coats of these colours will be sprayed on top of one another, a huge number of mixed shades will be obtained.

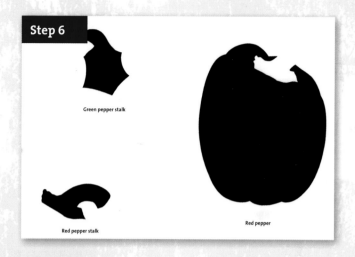

Step 6

Green pepper stalk

Red pepper stalk

Red pepper

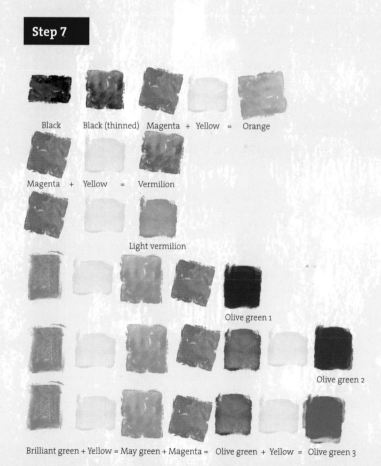

Step 7

Black Black (thinned) Magenta + Yellow = Orange

Magenta + Yellow = Vermilion

Light vermilion

Olive green 1

Olive green 2

Brilliant green + Yellow = May green + Magenta = Olive green + Yellow = Olive green 3

Step 8
It all begins with thinned black. Although the pepper is red, the first thing to do is to apply the shadow areas in thinned black.

Step 9
Shaping shadow areas by erasing. Working carefully with a rubber eraser and this time also with an eraser pencil, I add character to the surfaces by creating edges and textures. Any superfluous drawing lines (right-hand side) are also erased. The shadow areas must be finished before applying colour.

Step 10
Red ripens up the pepper. The shaded areas remain and dark vermilion is sprayed on top, which ripens the body of the pepper. No further changes can be made to the shadows at this point.

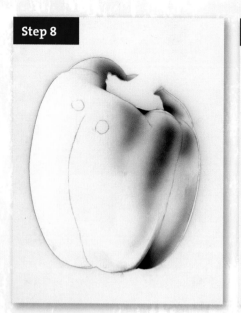

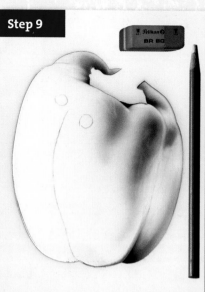

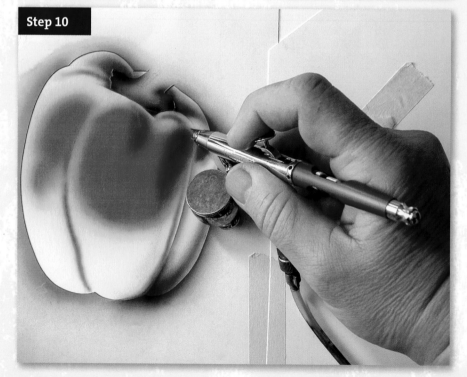

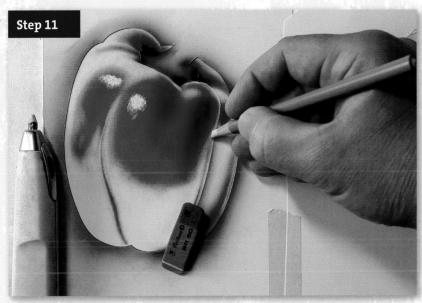

Step 11

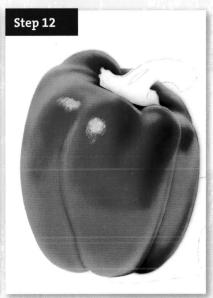

Step 12

Step 11

Making inroads into the red by erasing.
A rubber eraser, eraser pencil and even an electric eraser are used for the same purposes as in the shadow areas.

Step 12

Continuing with bright red.
Coat the whole pepper with this red. Different textures are created in the areas where the erasing has left highlights.

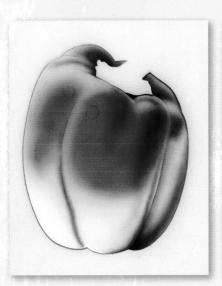

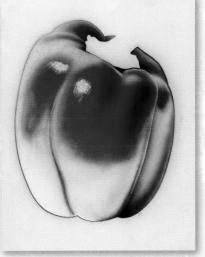

Comparison after work in steps 10 and 11.
Erasing has produced highlights that
add to the three-dimensionality of the image.

Step 13
Third stage of erasing.
The rounded-blade scalpel comes into action here to scrape some of the light red for the final reflections and highlights.

Step 14
Creating the stalk.
The procedure is the same as for the body of the pepper, but in green. Again, however, you start with the black for the shadow areas.

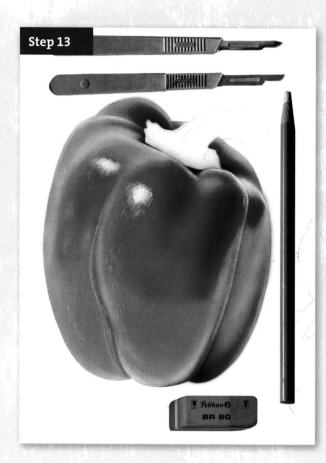

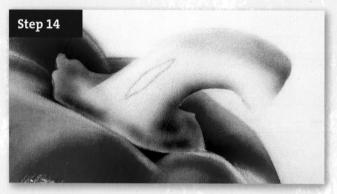

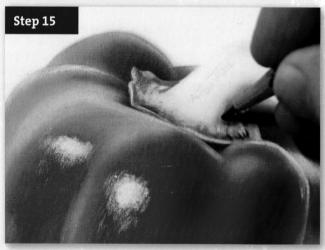

Step 15
Eraser pencil and coloured pencil add accents.
By using an eraser pencil, you create light textures. For something new and special, add shading with a dark green coloured pencil.

Step 16
First paint application.
Starting in part with dark olive green.

Step 17
Second paint application.
A light May green is sprayed over the
entire stalk.

Step 18
Final highlights and textures.
The stalk is beginning to shine. Linear and spot
highlights are obtained using an electric eraser
and scraping scalpel. Use the dark green
coloured pencil again for the dark lines (as on
a cucumber).

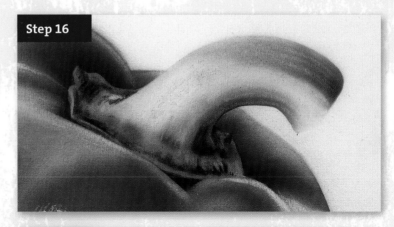

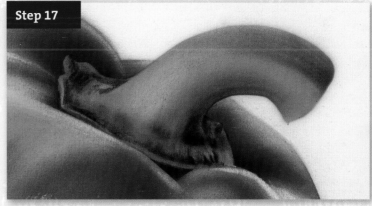

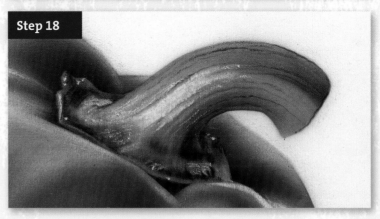

Step 19
Stencils for the green pepper.
Rub the outlines of this pepper (in exactly the same way as in step 6) from the sketch onto suitable material (cardboard, Pellon) and cut it out.

Step 20
Initial cast shadows and folds.
I have been using general purpose stencils (see picture on page 12) for years to airbrush these effects. This stencil has already been put to repeated use, as is clear from the green 'aura'.

Step 21
Initial colouring with olive green 1
(from the colour palette on page 75).
The green colour is applied in three stages. All the black is overcoated with this darkest green.

Step 22
Erasing technique for highlights and cast shadows.
All the previously black parts are oversprayed with green and can now only be changed mechanically. The soft highlights are created with the red end of a Pelikan BR 80 eraser, while the hard highlights are produced using an electric eraser.

Step 23
Second colouring with olive green 2.
The entire pepper is coloured using the lighter olive green 2. You needn't pay any attention to the dark green at this point because overspraying with the lighter olive green has almost no effect.

Step 19

Red pepper shadow

Green pepper shadow

Green pepper

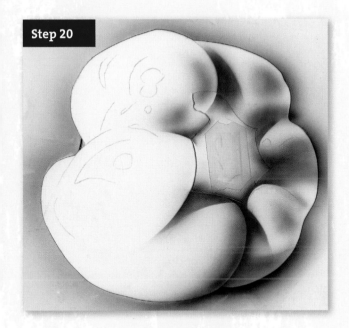

Step 20

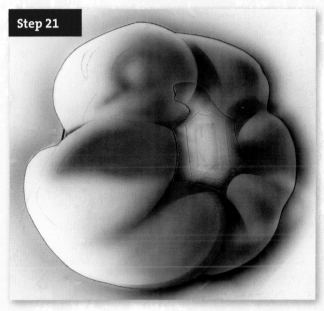

Step 21

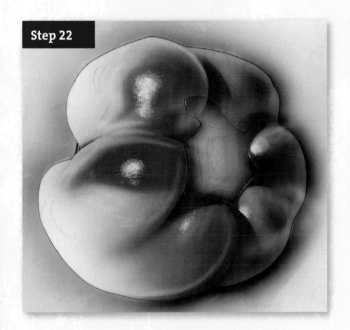

Step 22

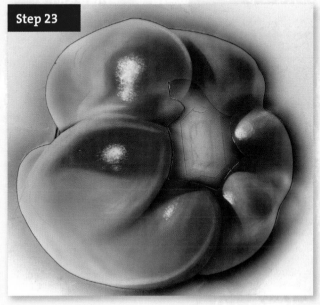

Step 23

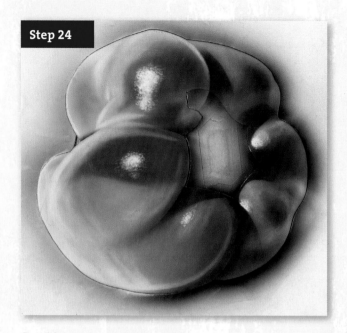

Step 24

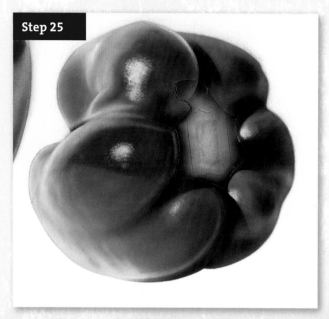

Step 25

Step 24
More erasing in olive green 2.
The primary aim here is to produce the soft streaks on the left-hand side.

Step 25
Colouring with olive green 3.
After the final paint application, the oversprayed highlights have to be lifted back up towards white using an electric eraser.

My opinion about black in airbrushing

Airbrushing pundits very often say that black should never be used. I think it's just a matter of knowing how to handle black properly. If you do as I do and always spray black as the first colour, then the finished illustration will have precisely the shadows and depth that are required.

Food for thought

The green pepper is of course produced in exactly the same way as the red one. Follow each step here as well and don't demand too much of yourself. It's fine to set targets, but they should be realistic. If they're out of reach, you'll fail and this won't boost your creative enthusiasm. Each exercise in this book builds on the previous one. Do all of them and you'll achieve some impressive results by the time you finish the book.

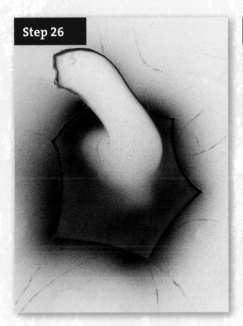

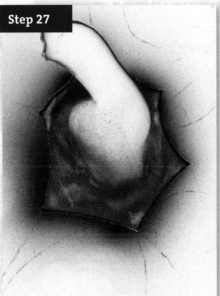

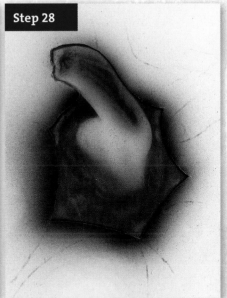

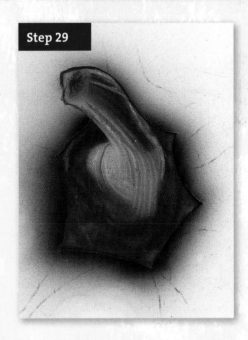

Step 26
Airbrushing the stalk black.
The same procedure as for the red pepper is initially used at the base of the stalk.

Step 27
Texturing the black.
The base of the stalk is not a smooth surface, so texture should also be created here with an eraser.

Step 28
Shaping the stalk with colour.
Olive green 1 is also used for this part of the pepper, but not before shading the curvature of the stalk and texturing its cut end with a dark green pencil.

Step 29
Final fine texture.
Use an eraser pencil to draw the light lengthwise streaks and a lighter green pencil to create the cucumber-like colouration of this stalk.

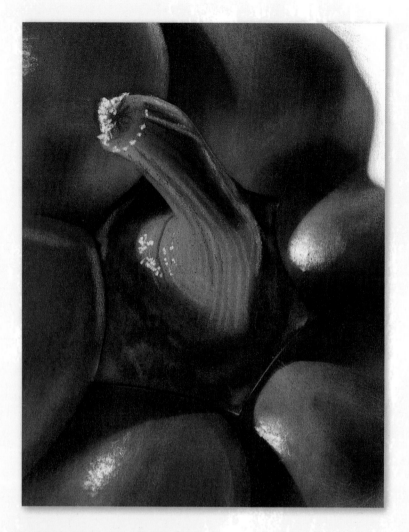

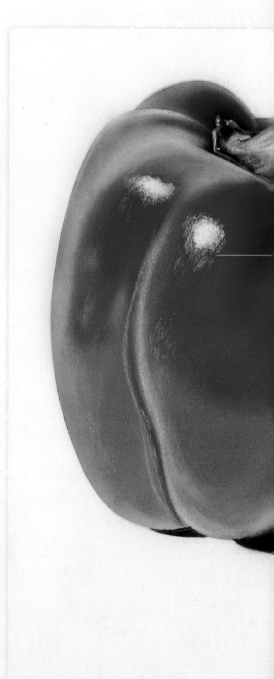

A perfect stalk.

The entire stalk is airbrushed with olive green 3 in the tone of the body of the pepper, and any necessary highlights are created using an electric eraser.

Red and green pepper, the finished illustration.

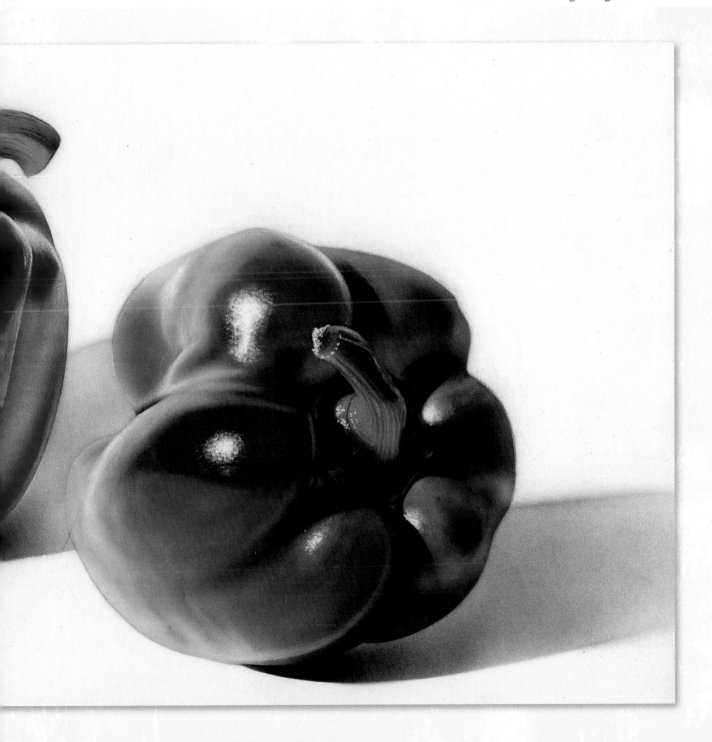

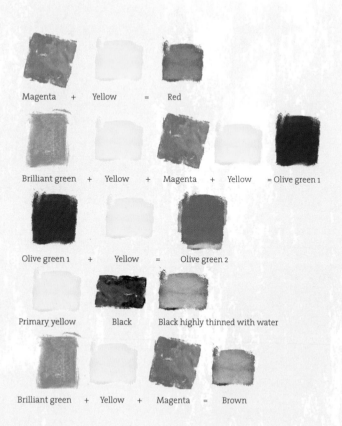

Magenta + Yellow = Red

Brilliant green + Yellow + Magenta + Yellow = Olive green 1

Olive green 1 + Yellow = Olive green 2

Primary yellow Black Black highly thinned with water

Brilliant green + Yellow + Magenta = Brown

Colour palette for fruit and leaves.
The colours are virtually identical to those used for the pepper exercise, the only additions being primary yellow and a brown for the stalk.

Example: Apple with two leaves

Step 1
Original photograph.

Steps 2 to 5
Transfer method.
This is the last time I'll give you a quick reminder. After this you'll know the procedure from drawing to rubbing down the original like the back of your hand. The front apple is the original for the exercise.

Step 6
Producing the stencils for the apple.
The templates are obtained from the sketch. The left-hand stencil is for the cast shadows, and the apple is masked with the second stencil (this can also be achieved with just one stencil).

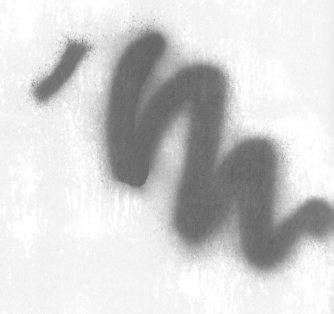

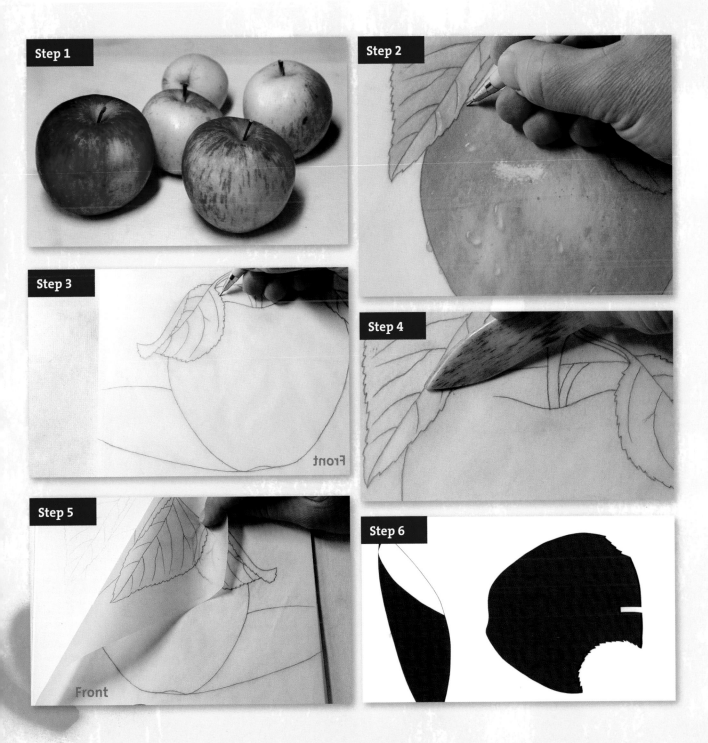

Step 1

Step 2

Step 3

Front

Step 4

Step 5

Front

Step 6

Step 7
First shadows.
The light coming from the top left casts shadows from the two leaves onto the apple.

Step 8
First paint application.
The base colour is applied using a cold red. Less paint is sprayed at the base of the stalk and in the middle.

Step 9
First light texturing.
The round shape of the apple is then created using the cut edge of the hard end of a rubber eraser.

Step 10
Spot texturing.
Another effect an electric eraser can create.

Step 11
Second paint application.
Using an airbrush, fine clouds are sprayed over the area to cover up excessively light textures.

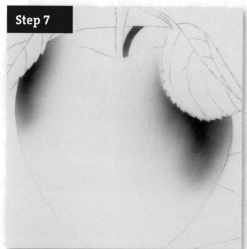

Step 7

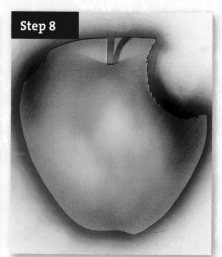

Step 8

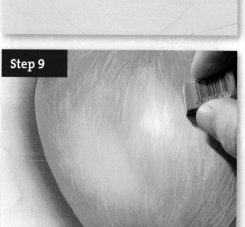

Step 9

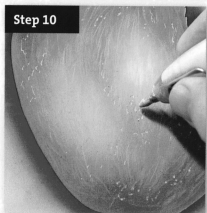

Step 10

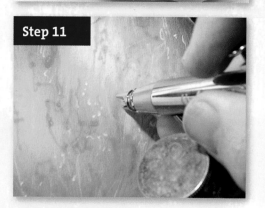

Step 11

◥ **Steps 12 and 13**
Speckling with a toothbrush.
First, small red flecks are applied, which are then followed by yellow ones. The yellow ones are applied using a special technique: a couple of drops of opaque white are mixed into the transparent yellow, producing an opaque yellow that covers the darker red.

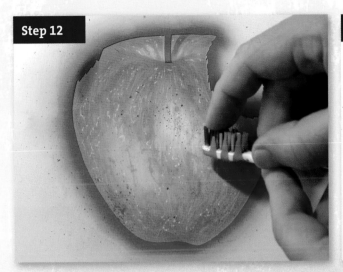

Step 12

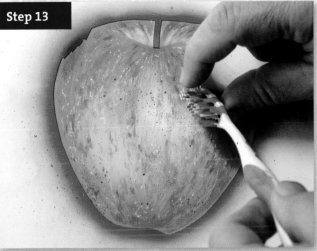

Step 13

Speckling

Speckling is a way of producing additional texture. Toothbrushes or bristle brushes are suitable for this purpose. Some airbrush manufacturers also offer special speckling caps for their equipment, but you can achieve the same effect with a toothbrush or paintbrush.

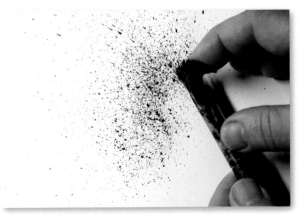

Speckling with bristle brush and finger.

Speckling with a bristle brush stroked over a mesh.

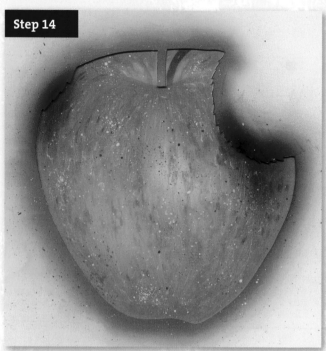

Step 14

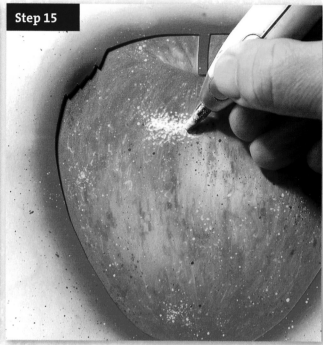

Step 15

Step 14
Third paint application.
The now fully textured apple is coloured overall with transparent yellow. This final application of yellow was taken into account when mixing the red shade in step 8. This full application of yellow colouring makes the previously 'cold' red into a warm red with a yellow content. In addition, the areas where no or only very light red has been applied are now yellow, so two tasks are accomplished with one spraying operation.

Step 15
The final texture.
These highlights, produced with the electric eraser, show that the apple has a shiny surface. If you want a matt surface, omit this step.

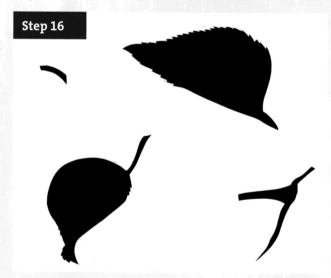

Step 16

The apple is finished.

All that remains to be added is the stalk and the two leaves. The space for the right leaf has been left blank (it looks as if a bite has been taken out of the apple!). I will only describe production of the left leaf, and indeed only its left-hand side, in any detail. The same procedure is used to produce the right-hand side of the left leaf and the entire right leaf.

Step 16

Stencils for the leaves.

Like the apple itself, these are transferred from the sketch and cut out.

Step 17

Producing the ribs.

These are sprayed in olive green using a general purpose stencil, which is moved a little for each rib.

Step 18

Colouring and shading.

The whole leaf is sprayed in soft pastel olive green 1, and the ribs are emphasised with a dark green coloured pencil.

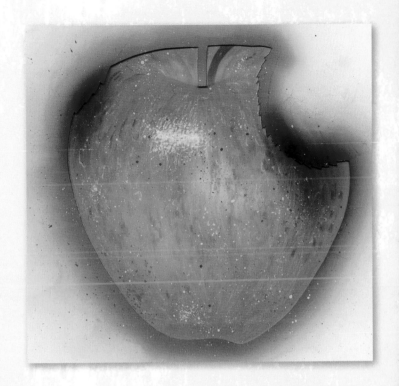

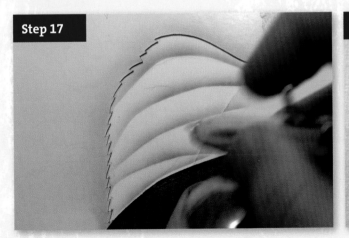

Step 17

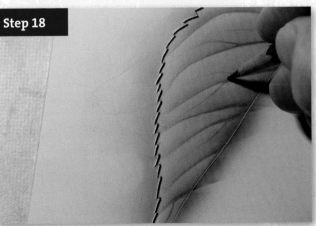

Step 18

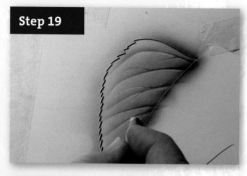

Step 19

The first texture.

Individual highlights are exposed using the eraser pencil.

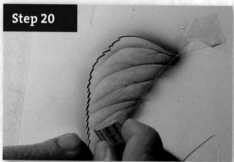

Step 20

Colouring and shading.

I use the rubber eraser to produce textures.

Step 21

Adding the apple and leaf stalks.

Use the stencil from step 16 to cover up the apple. The side leaf stalks are coloured green and the apple stalk is black.

Step 22

The third texture.

Small speckles applied using a red-brown coloured pencil make the stalk look very realistic.

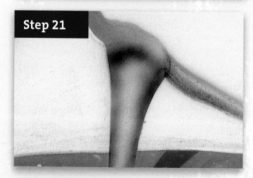

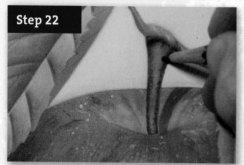

Step 23

Finishing touch.

Use the electric eraser to add the final highlights to the stalk.

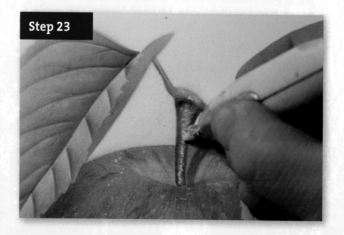

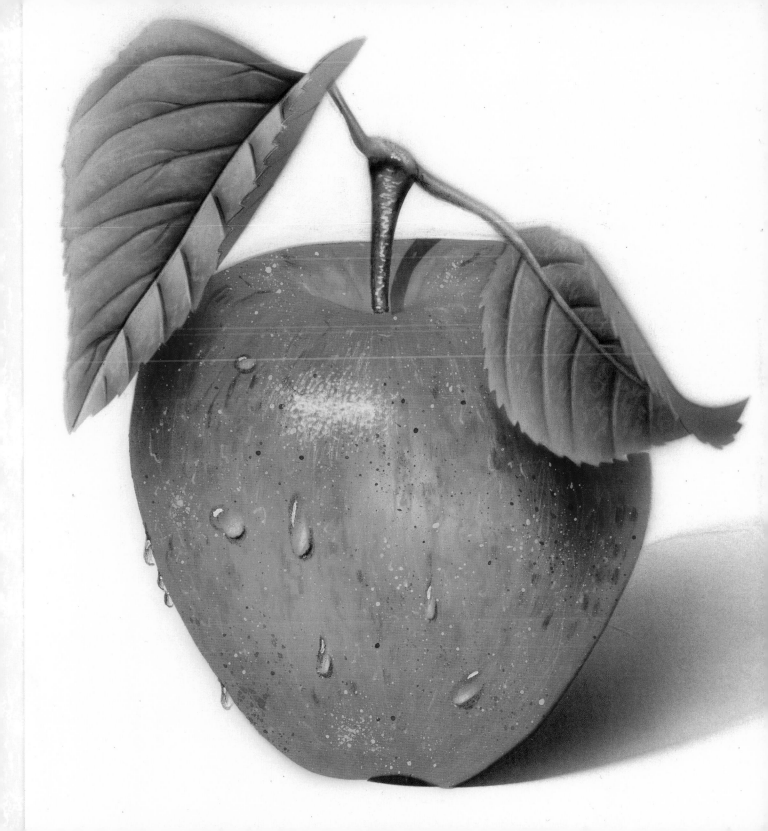

Example: Bananas, peeled and as they come

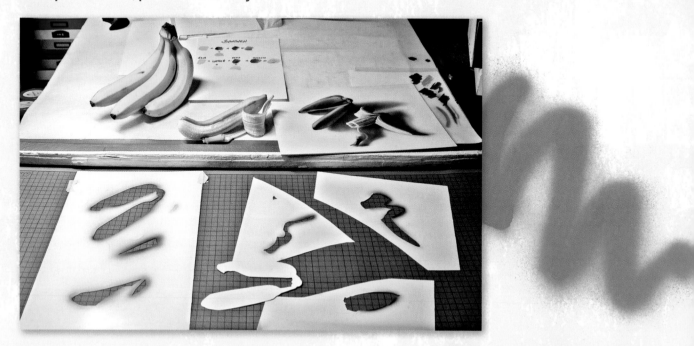

My workspace: the process of airbrushing a banana.
I have pushed the work surface (an enamelled insulating board) away and up simultaneously, as I work on a sloping surface. At the bottom you can see my cutting mat, a luxury I would highly recommend for cutting stencils. The arrangement of the bananas (the bunch and the half-peeled one) almost matches the photo that I used for the sketch in step 1.

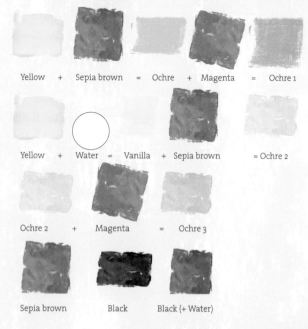

Yellow + Sepia brown = Ochre + Magenta = Ochre 1

Yellow + Water = Vanilla + Sepia brown = Ochre 2

Ochre 2 + Magenta = Ochre 3

Sepia brown Black Black (+ Water)

The colour palette with instructions for mixing.

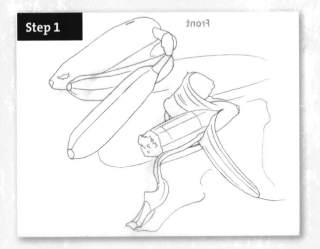

Step 1

Front

Step 2

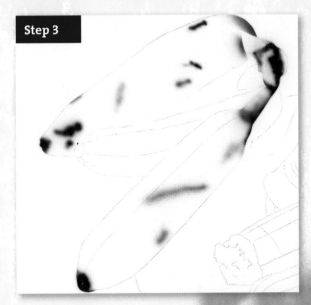

Step 3

Step 1
The sketch.
This was produced from a photo using the transfer method described above and was used as the basis for the rest of the work.

Step 2
The stencils.
Transferred and cut out from the sketch.

Step 3
First paint application.
The darkest parts, bruises and age marks, are sprayed in black.

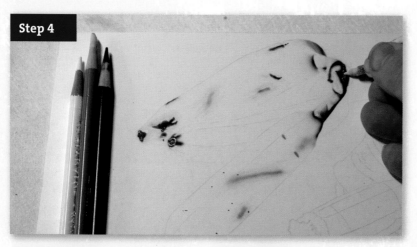

Step 4

Step 4
First texturing.
A coloured pencil is used to deepen the colour, and then the dark spots are textured using an electric eraser and eraser pencil.

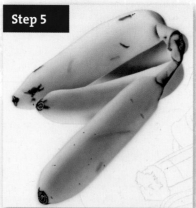

Step 5

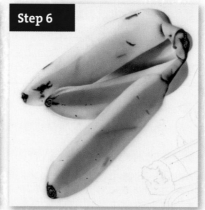

Step 6

Step 5
Second paint application.
Highly thinned black is used to provide a soft grey on the bananas for self shadows, and a darker shade is used for the shadows cast by the fruit.

Step 6
Second texturing.
By erasing the grey the bananas are given their characteristic, slightly angular shape.

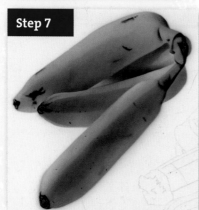

Step 7

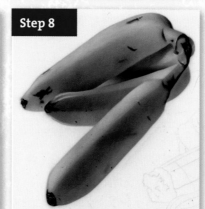

Step 8

Step 7
Third paint application.
The familiar banana look is produced using sepia brown and yellow.

Step 8
Third texturing.
Only a few highlights need to be erased owing to the generally matt surface of banana skins. These are clearly visible on the middle banana and the cut face of the stalk; they are only really soft on the upper banana, which becomes somewhat lighter as a consequence.

The peeled banana

Step 9

First paint application and texturing.

Except for the dark shadow part, two different colours are sprayed on for the peeled banana: light grey (from thinned black) for the flesh of the fruit and a watery yellow for the inside of the skin. Textures and cracks are produced in both using the electric eraser. The hints of fibres are produced using a reddish-brown coloured pencil.

Step 10

Second paint application.

The fruit flesh is completely oversprayed with a watery yellow. Added texture is produced at the end of the fruit using a brown pencil, and the skin is defined using a black pencil.

Step 11

Second texturing.

Once the fruit pulp has been oversprayed, clearer contours are again produced by adding highlights with the electric eraser.

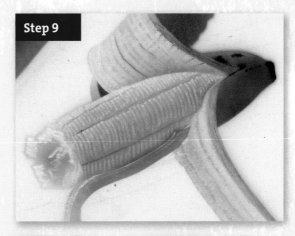

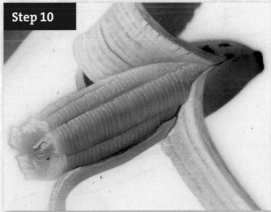

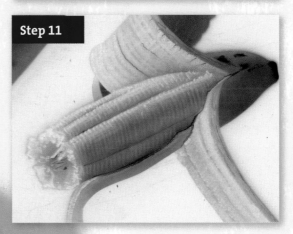

Step 12

Preparatory work for spraying the cast shadow.
The complete illustration is covered with airbrush film. I carefully cut the shape of all the bananas out with a scalpel. Then I can remove the film covering the background around the bananas, leaving just the bananas themselves masked. The shadow can now be airbrushed.

Step 13

Third paint application.
The cast shadow is sprayed freehand around the bananas in dilute black and the yellow shades I had mixed for the bananas. These yellow shades are necessary because the bananas are lying on a white background and this reflects the colours of the fruit. In this photo the fruit flesh looks so dark because it was oversprayed while it was under the masking film.

Step 14

Third texturing.
The masking film is still in place. The shadow is given its final shape with an eraser.

Step 15

The masking film is removed.
When the dark oversprayed film is peeled off, the fruit flesh is once again visible in all its brightness.

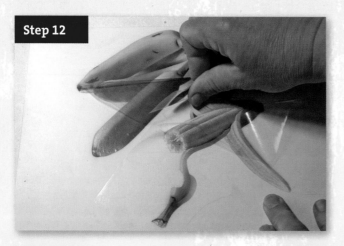

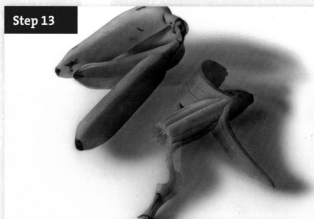

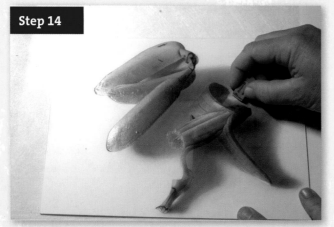

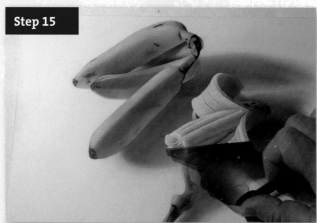

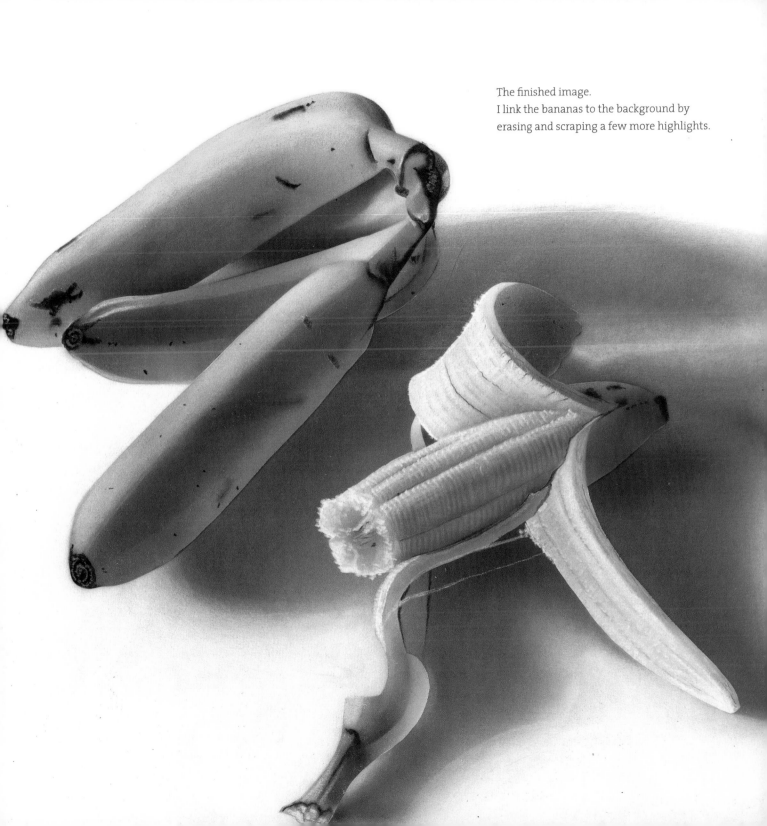

The finished image.
I link the bananas to the background by
erasing and scraping a few more highlights.

Picture compositions using various techniques

The last chapter of the book deals with larger illustrations, which are produced using various methods you already know but also using new techniques and materials. The tools used include opaque white, paintbrushes, eyedroppers and special stencils for the starry sky. However, first of all we'll take a look at the various ways of reproducing water droplets, which play an important part in this illustration.

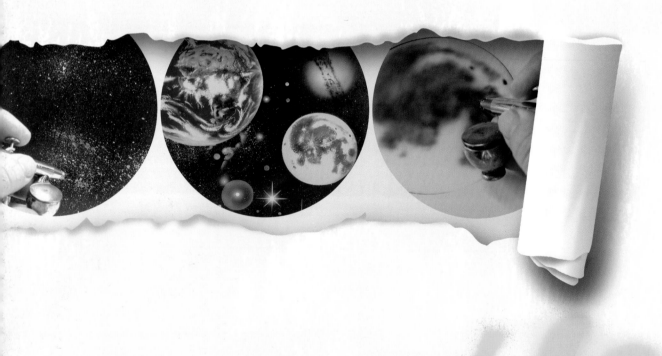

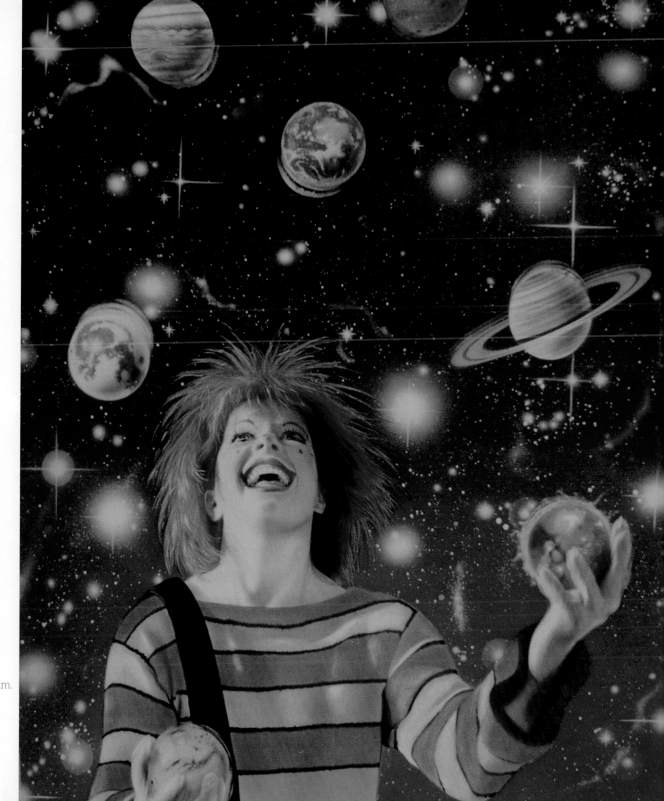

Antoshka's dream.
Antoshka the
clown juggles
the planets.

Preparatory work: Water droplet

A water droplet is really easy even for beginners, though it may not look it at first glance. There are various ways of reproducing them, which all lead to exactly the same goal.

The motto 'less is more' is very relevant here – it's easy to do too much too quickly and end up with a droplet that no longer looks realistic. You only see a water droplet because on the one hand it casts a shadow, and on the other it reflects any available light source.

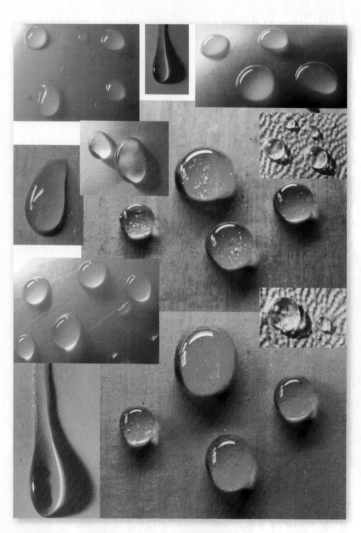

Water droplets in their many forms.

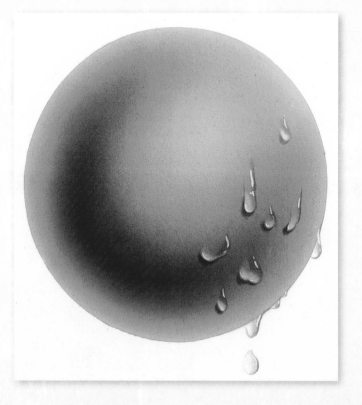

A red ball with water droplets in various shapes and sizes.
The highlights and shadows look very different depending on their position on the sphere.

The first option: Coloured pencil and opaque white

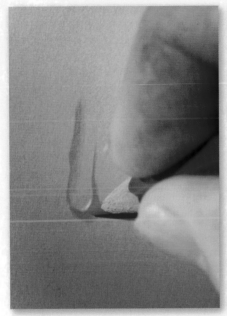 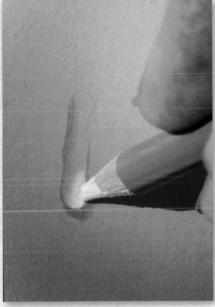 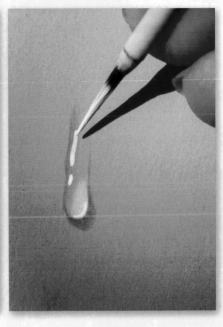

Drawing with a coloured pencil.
The elongated droplet is made more three-dimensional by adding a shadow with the coloured pencil.

Working with the eraser pencil.
The highlight is formed with an eraser pencil.

Using opaque white.
Opaque white is painted on with a paintbrush to achieve the pure white highlight.

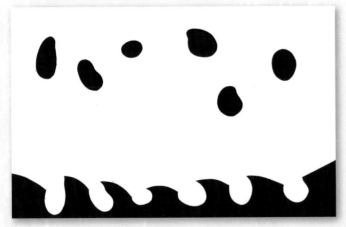

A stencil for differently shaped water droplets.

The second option: Airbrushing and erasing

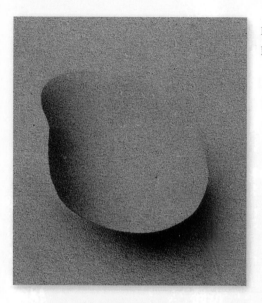

Both the self shadow and the cast shadow are produced by airbrushing.

The diffuse highlight at the bottom right is erased with the soft end of the rubber...

... and the sharply defined highlight is produced using the electric eraser.

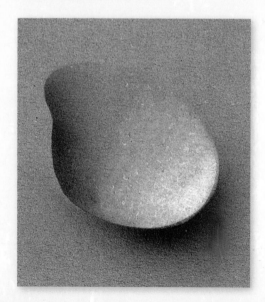

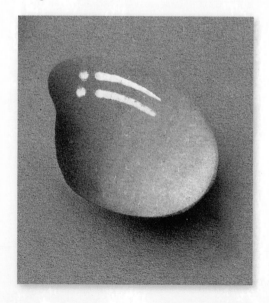

The third option: Airbrushing and opaque white

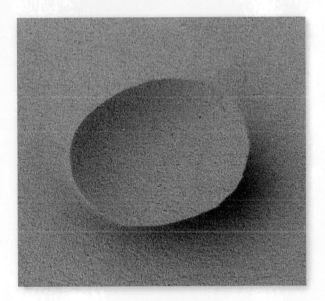

Self and cast shadows are produced by airbrushing.

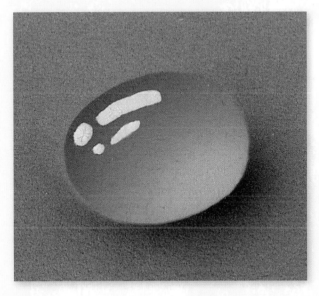

Opaque white is used twice: the diffuse highlight is airbrushed with it, and the sharply defined highlight is painted on with a paintbrush.

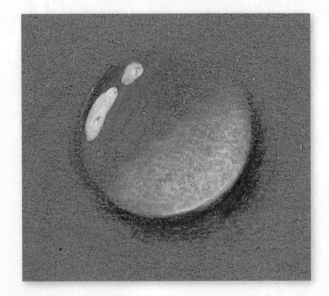

The fourth option: Combining all the techniques

In this case the shape is airbrushed, the light side is erased with the soft rubber, the highlights are painted on in opaque white and all the shadows are drawn on with coloured pencils. As you can see, there are many different ways of reproducing water droplets.

Space – a sky full of stars

This subject gives you a great result quickly and will encourage you to continue. You can play around with this a lot without really going wrong.

Speckling small stars

We have already covered speckling in the exercise with the apple; here it is an essential technique! In the following images, the dark universe against which the stars will shine is obtained using black, ultramarine and cyan.

There are several ways of producing a varied starry sky. It can be produced by speckling onto the dark background either solely with opaque paints or with transparent paints made opaque by the addition of opaque white. The layers of light and dark stars give the picture the spatial depth which characterises infinite space.

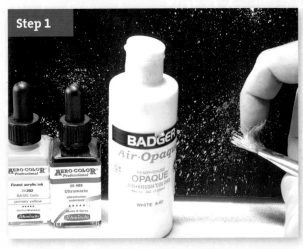

OPTION 1 ▲
Step 1
Starry sky using only opaque acrylic paints.
If you generally work with transparent paints, there is no point in specifically buying an opaque paint just to speckle on a few stars. All you need to do is add a few drops of opaque white to your transparent paint, hence making it opaque.

OPTION 2 ▶
Step 1
Speckling with opaque white and overspraying with ultramarine. Speckled with opaque white and oversprayed with ultramarine. This is what the sky looks like if pure opaque white is speckled onto the dark background and then a few areas are oversprayed with transparent ultramarine.

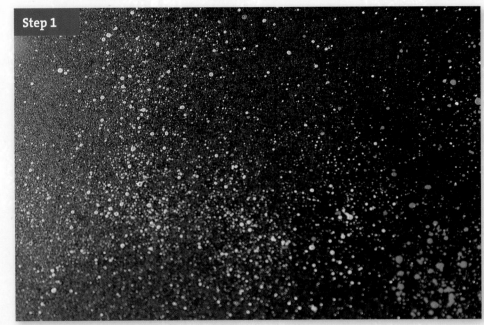

Step 2

Opaque white and overspraying with cyan.

Speckling again with opaque white and overspraying with lighter, transparent cyan results in spatial depth, because the bluish stars recede into the background.

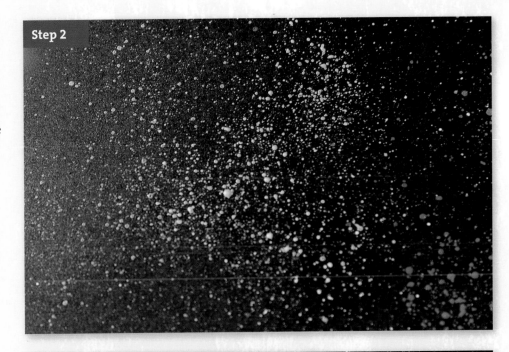

Step 3

Final speckling with opaque white.

The unblemished white makes the night sky glitter and gives the desired depth.

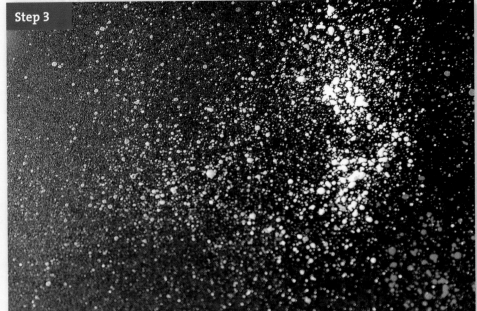

Stencilling large stars

Larger stars with rays and a halo can only be produced using stencils.

Space 1

A view of the night sky with a profusion of shining stars.

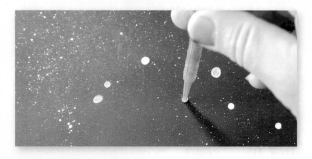

Working with the eyedropper.
Use this to produce an opaque white base for larger stars.

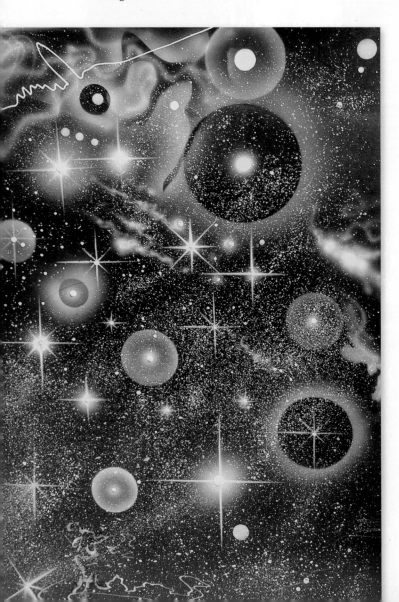

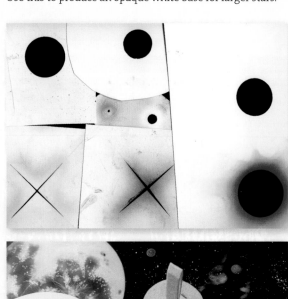

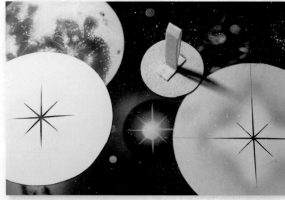

Cardboard stencils for airbrushing stars.
The stencil with the handle is used for the halos round the stars.

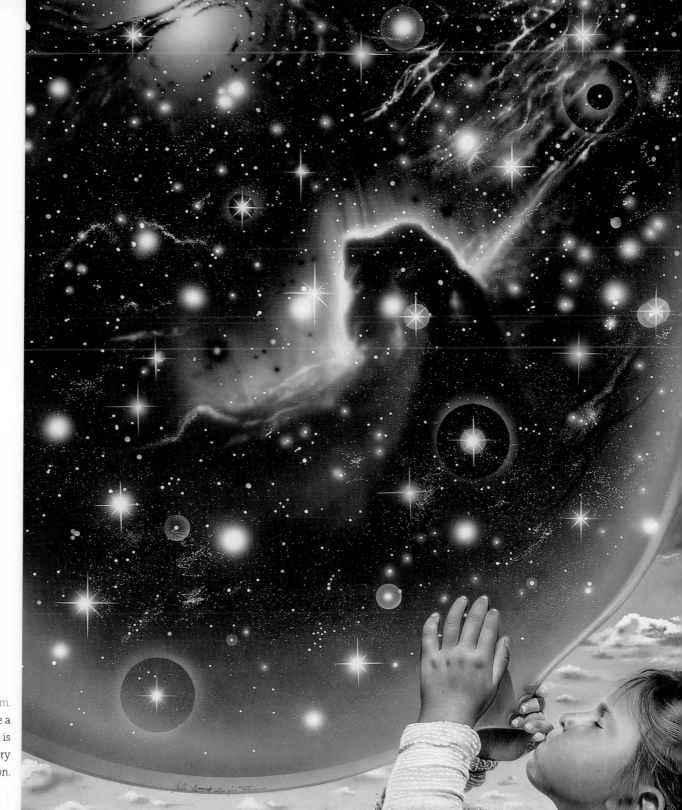

Helena's dream.
In this piece a
young girl is
inflating a starry
galaxy like a baloon.

Creating the moon

This is not about creating an accurate reproduction of the moon; it is more about showing how the earth or a celestial body close to the earth can be textured so as to make it recognisable.

Step 1
Shadow stencil.
Cut a stencil with a circular opening into which dark blue shadows can be airbrushed.

Step 2
Working with the electric eraser.
Using the electric eraser, first of all form a series of round, dot-like textures. Softer textures, for example for crater edges, can be formed using the rubber eraser, and smaller crater holes can be formed with the eraser pencil.

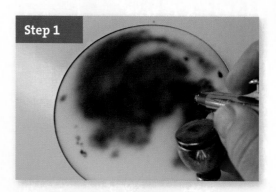

Step 1

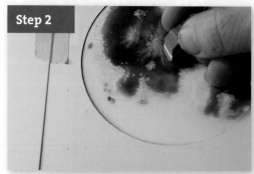

Step 2

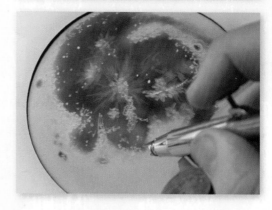

Space 2
An imaginative space scene, dotted with the earth, moon and stars.

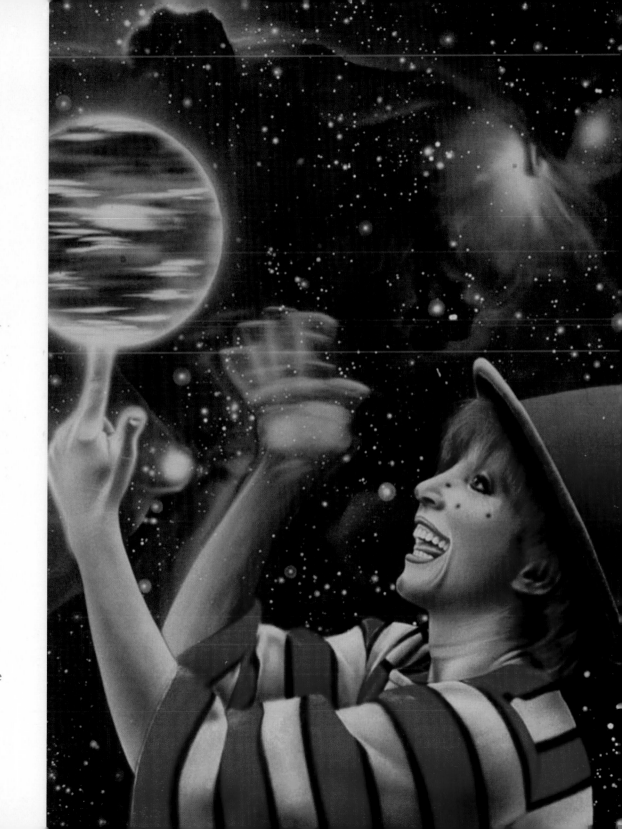

Antoshka's dream.
This is a variation of the
opening piece to this
chapter on page 101.

About the author

Meinrad Martin Froschin is a freelance artist living in Augsburg, Germany.

He worked as a textile designer for seventeen years before becoming a freelance illustrator in 1993. Since then he has worked with a variety of art forms and specialises in airbrushing: custom painting, body painting, trompe-l'oeil, and wall and textile design.

Meinrad now runs workshops all over Germany and has been published in various German trade publications. He has also released various DVDs and two videos entitled *Photorealistic Portraits,* available in German.

www.froschin.de

Acknowledgements

Thank you to my sisters Lydia, Silvia and Tanja for your help and support, and
to Uschi Eschbach, with whom I have had the honour to work creatively for over ten years
and who knows an artist's dark side and how to deal with it.
Thank you to Mr. Braun, with whom it has been great fun to work.

Publishing details

First published in Great Britain in 2015
by Search Press Limited, Wellwood, North Farm Road, Tunbridge Wells, Kent TN2 3DR

Original German title *Airbrush Technik: Die Grundlagen für das Arbeiten mit transparenten Farben*

Copyright © Edition Michael Fischer GmbH, Igling, Germany 2013

This translation of AIRBRUSH TECHNIK, first published in Germany by Edition Michael Fischer GmbH in 2013, is published by arrangement with Silke Bruenink Agency, Munich, Germany.

Text copyright © Meinrad Martin Froschin and Manfred Braun

English translation by Burravoe Translation Service

ISBN: 978-1-78221-119-8

Printed in China